Mastering MANGA 3

POWER UP

with Mark Crilley

IMPACT
CINCINNATI, OHIO
impact-books.com

Contents

Part 3
Finishing Touches
page 94

Conclusion

Index

About the Author

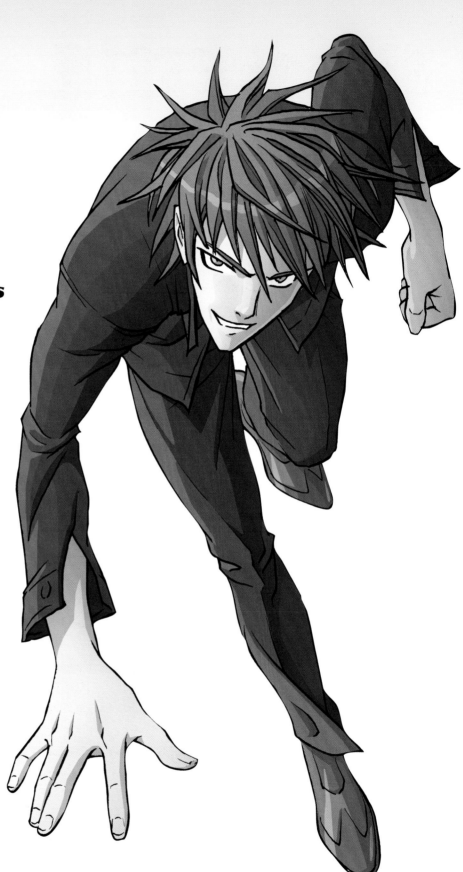

Introduction

Hey there, everybody! I'm Mark Crilley.

When I sat down to create *Mastering Manga 3*, I knew I had to take things to another level.

The first two books in the series focused on the basics.

I wanted most of the lessons to be doable even for absolute beginners.

This time, I've decided to take on drawing methods that are more challenging…

…distinctive styles that require patience and attention to detail.

This third book also allows me to get into a whole range of new topics…

…things that were just a little beyond the scope of the first two books.

Like methods of adding color…

…how to draw manga-style animals…

…the ways artists use photo reference…

…and much more.

As usual, let's start by looking at the art supplies you'll need if you want to follow along with these lessons.

What You Need

Many aspiring artists worry too much about art supplies. There almost seems to be the belief that buying the right stuff is the single most important key to creating great art, but that's like thinking you'll be able to swim as fast as Olympic gold medalists do by wearing the right swimsuit. It doesn't work that way.

What really matters is not the pencil but the brain of the person holding it. Experiment to find the size, styles and brands you like best. If it feels right to you, that's all that matters.

Paper

I almost want to cry when I see that someone has put hours and hours of work into a drawing on a piece of loose-leaf notebook paper. Do yourself a favor and get a pad of smooth bristol. It's thick and sturdy and can hold up to repeated erasing.

Pencils

Pencils come down to personal preference. Perfect for me may be too hard or soft for you. I like a simple no. 2 pencil (the kind we all grew up with), but there are pencils of all kinds of hardness and quality. Try some out to see what kind of marks they make. The softer the lead, the more it may smear.

Pens

Get a good permanent ink pen at an art store, one that won't fade or bleed over time. Don't confine yourself to superfine tips. Have a variety of pens with different tip widths for the various lines you need.

Rulers

Get yourself a nice, clear plastic ruler so that you can see the art as you make lines. A 15-inch (38cm) ruler is good for even some of the longest lines.

Kneaded Erasers

These big soft erasers, available in art stores, are great for erasing huge areas without leaving tons of pink dust behind. However, they aren't always precise, so feel free to use them in combination with a regular pencil eraser.

Pencil Sharpeners

I've come to prefer a simple handheld disposable sharpener over an electric one. You'll get the best use out of it while the blade is perfectly sharp.

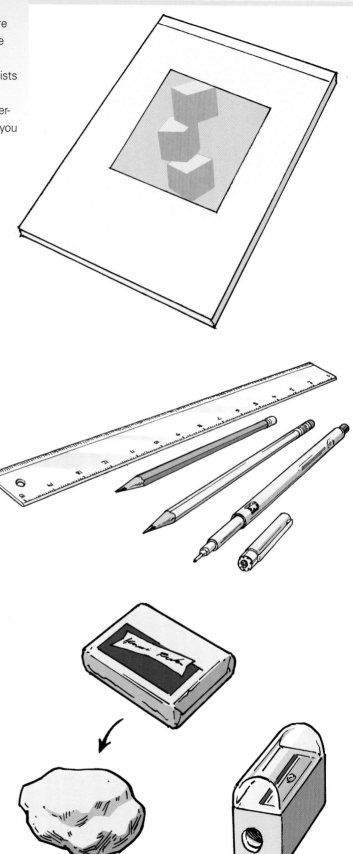

Making the Manga Eye

Let's begin with a little practice step-by-step demonstration. This will help you get used to the approach I'll be using throughout the book. By now it's a tradition of mine to devote this first lesson to manga eyes. For

Mastering Manga 3 I've decided to challenge you with a pair of eyes that are more detailed than the ones I've presented in the previous books.

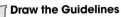

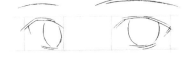

1 Draw the Guidelines
Draw two horizontal lines about 1 inch (25mm) apart. Connect them with four vertical lines to create the three rectangles you see here. Note that the left rectangle is pretty close to being a square, while the one on the right is quite wide.

2 Draw the Basic Shapes
Draw the eyebrows and the basic shapes of each eye, paying close attention to how the eyes fit into the rectangles. The eye on the left is turned away from us, so everything about it, including the iris, is very narrow from side to side.

3 Start Adding Details
Now add details to the irises of each eye: pupils and at least two highlights. The highlights should be in the same location within each iris. Also add lines for the eyelid folds above each eye. Manga artists often have these lines fork a little at either end as I have done here.

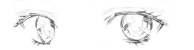

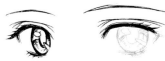

4 Add the Final Details
Time to go for the details. Add lines to thicken the eyelid lines, then add the eyelashes, taking care to have the lines fan out a little as they extend from the eyelids.

Then put some shading in the upper half of each iris. Make it your own—no need to do exactly what I've done here.

5 Ink the Drawing
Grab your favorite ink pen and begin inking all the lines. Take your time and try to ink in a smooth, relaxed way. My approach is to use thick lines in the area of the eyelashes and thin lines for the folds above the eyelids.

6 Erase the Pencil Lines
Allow plenty of time for the ink to dry—the last thing you want to do is smear it! Then erase all the preparatory pencil lines. Nicely done. Now you're ready to take on the more challenging lessons ahead.

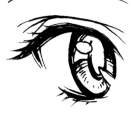

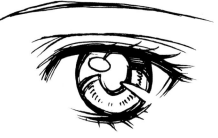

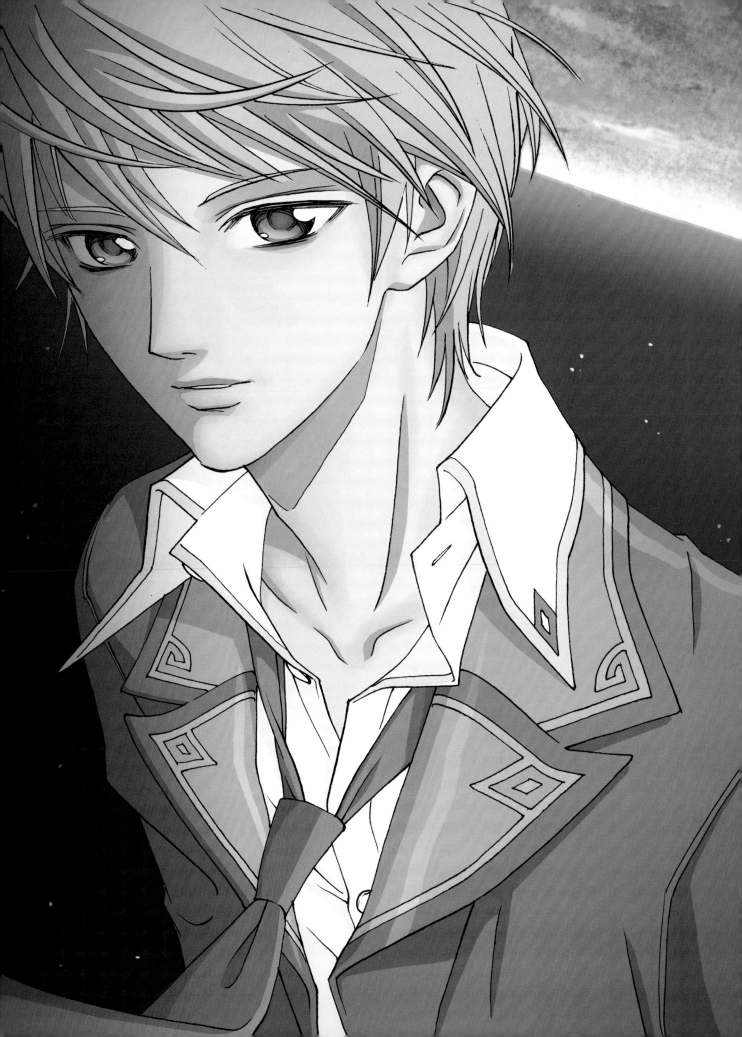

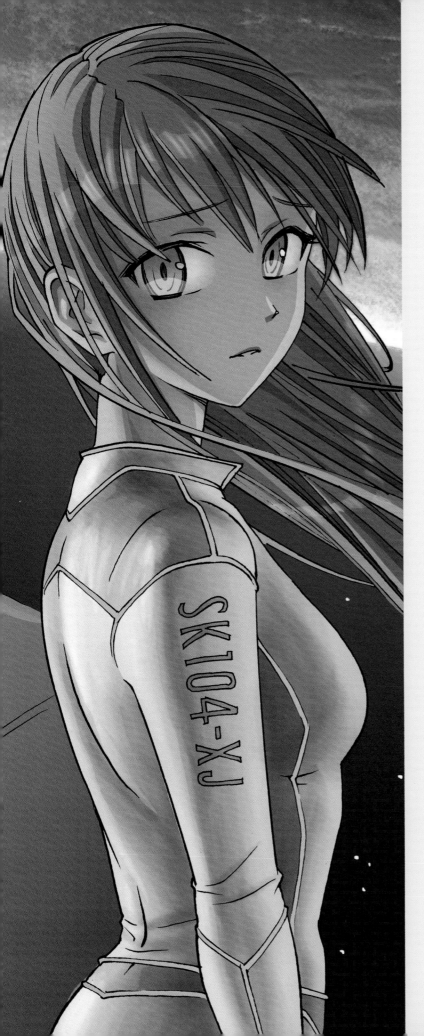

Characters and Styles

At the heart of every manga story is its characters and the style in which they are drawn. If someone were to ask you what it is that makes a certain manga series your favorite, chances are one of your answers would be, "I like the characters, and I like the art style." So when it comes to making your own manga drawings, these two topics have to be a top priority.

In the chapter ahead you will embark on a thorough study of a wide variety of both characters and styles. In doing so, you'll begin to learn how to make your own manga characters the best they can be.

Drawing Styles

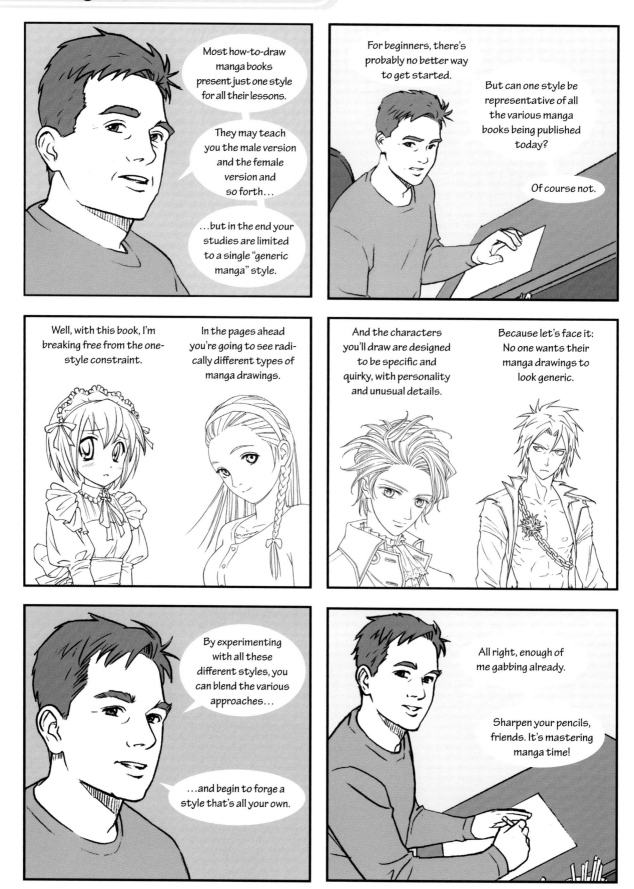

Most how-to-draw manga books present just one style for all their lessons.

They may teach you the male version and the female version and so forth...

...but in the end your studies are limited to a single "generic manga" style.

For beginners, there's probably no better way to get started.

But can one style be representative of all the various manga books being published today?

Of course not.

Well, with this book, I'm breaking free from the one-style constraint.

In the pages ahead you're going to see radically different types of manga drawings.

And the characters you'll draw are designed to be specific and quirky, with personality and unusual details.

Because let's face it: No one wants their manga drawings to look generic.

By experimenting with all these different styles, you can blend the various approaches...

...and begin to forge a style that's all your own.

All right, enough of me gabbing already.

Sharpen your pencils, friends. It's mastering manga time!

Creating Your Own Character

One of the joys of storytelling is that it allows you to breathe life into characters. There's nothing like that feeling you get when you've made a being come alive on the page. If you're like me, you find yourself coming up with characters just for the sheer pleasure of it.

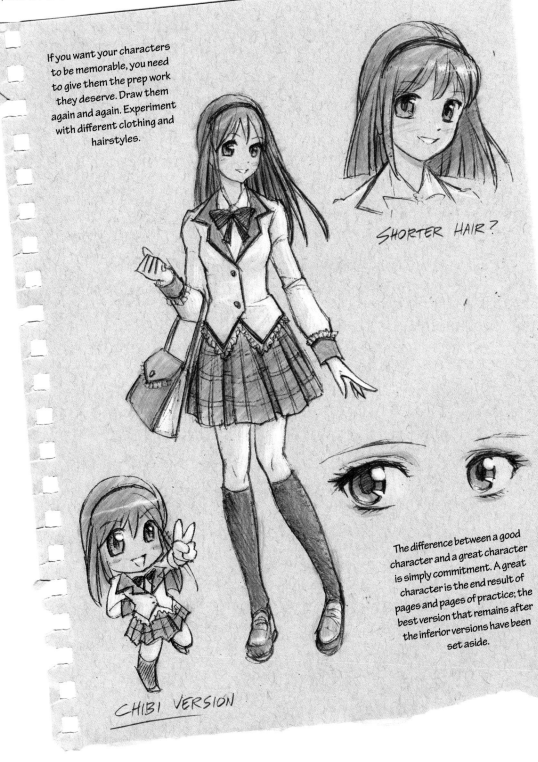

If you want your characters to be memorable, you need to give them the prep work they deserve. Draw them again and again. Experiment with different clothing and hairstyles.

SHORTER HAIR?

The difference between a good character and a great character is simply commitment. A great character is the end result of pages and pages of practice; the best version that remains after the inferior versions have been set aside.

CHIBI VERSION

Shojo Cuteness

One of the most popular ways of drawing in Japan is the *shojo* style. Used for books that are primarily aimed at a female readership, it's the ideal manga style for high school romances, slice-of-life tales and any story that focuses more on emotions than on packing in action scenes.

In this lesson, you will learn how to draw a shojo-style character. The eyes are large and highly detailed, and the line work is light and delicate. Eager to invent your own shojo character? Now's your chance: Change the details and make it your own!

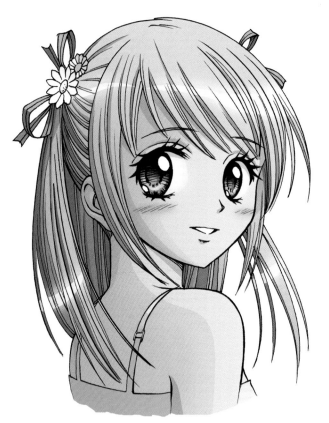

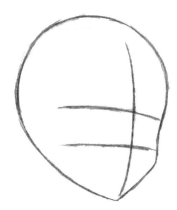

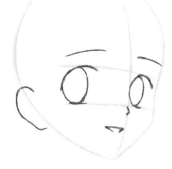

1 Mark the Head Guidelines

Begin by drawing a basic head contour in a three-quarter view. The shape is nearly as wide as it is tall. Add two horizontal lines for placing the tops and bottoms of the eyes. The higher of these two lines is about halfway between the top of the head and the chin. Then add a curving vertical line to help place the nose and mouth.

2 Draw the Basic Features

Draw the eyes. The character is turning away from us but looking back, so the two oval-shaped irises are shifted to the side of each eye. Note that because the eye on the right is farther away, it is smaller than the eye on the left. Experiment with your placement of the nose, mouth, ear and eyebrows. You may find that you prefer how they look in slightly different locations.

3 Add Details to the Features

Add details to the eyes and to the ear. Use small circles at the edges of the irises to create white highlights, which will make the eyes appear shiny later on. I've chosen to make the pupils quite large, but you may decide to make them smaller. A single line drawn above each eye indicates the fold of the eyelid.

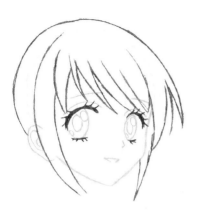

4 Draw the Hair and Eyelashes

Add lines for the hair. Be creative—no need to have it look exactly as it does here. Just try to make the lines follow along with the crown of the head, curving to the left and to the right to reveal the shape of the scalp beneath. For an extra-feminine look, add eyelashes. Often the upper eyelash is more prominent than the lower one.

5 Draw the Neck and Shoulders

This over-the-shoulder pose is well worth learning: It's an attractive and visually interesting way of presenting your character. To draw it accurately, note the width of the neck and the distance between the chin and the shoulder.

6 Add Hair Details

Add lines to the hair, breaking the larger shapes into smaller individual strands. When hair has been pulled up into a pigtail, the parts near the roots follow the surface of the head beneath. I added ribbons to give a sense of innocence to the character.

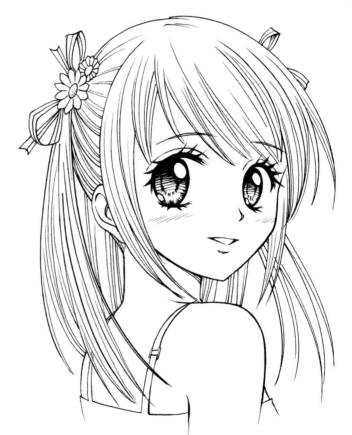

7 Add More Details to the Hair and Eyes

Continue adding lines to the hair and to the eyes. You can make the hair as detailed or as simple as you like. I added shading to the edges and the tops of the irises to give the eyes greater depth.

8 Ink the Drawing

Switch from pencil to pen, and ink all the lines. Try inking the hair with quick, loose strokes of the pen to get the smoothest possible line work. Allow plenty of time for the ink to dry, then erase away all the pencil lines. Congratulations! You've drawn an authentic shojo character, start to finish.

Shojo Elegance

Just because people speak of a "shojo style" doesn't mean that all shojo illustrations look exactly the same. Every shojo artist brings his or her own unique flair to it. For this lesson I want you to try out one more version of the shojo style. By choosing to use different facial proportions and line work, we can create a character that is miles away from the cute and innocent girl we drew earlier. He has an air of mystery and perhaps comes from a world very different from our own.

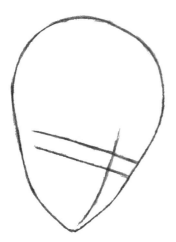

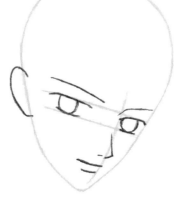

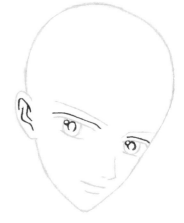

1 Mark the Head Guidelines
Start with the basic head shape. This time the head is significantly taller than it is wide, tapering quite a lot toward the chin. Again we need two lines for placing the eyes, but this time they are less widely spaced, and both are a bit lower on the head. Add a curving vertical line for placing the nose and mouth.

2 Draw the Basic Features
Draw the basic lines of the eyes, eyebrows, nose, mouth and ear. Note that the nostril is just a simple little dash—this is often the best way to do it. The ear is placed higher on the head than in our previous lesson.

3 Add Details to the Features
Add details to the ear and to the eyes including an eyelid fold above each eye as we did before. This time there is just one small highlight in each iris since we're not going for a sparkly, shiny look. The structure of the ear is conveyed with three interlocking lines. Take your time to get each of them in just the right place.

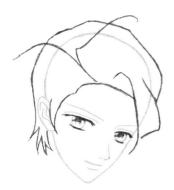

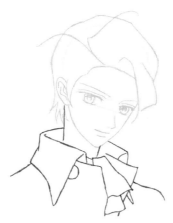

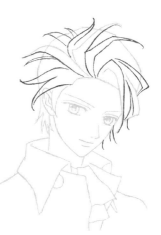

4 Draw the Hair and Eyelashes
Add the basic lines of the hair. Be creative and try altering the hairstyle to suit your own tastes. In shojo comics even the male characters have fairly feminine-looking eyes, so I've darkened the eyelashes here and put shading into the tops of both irises.

5 Draw the Neck and Shoulders
I dressed my character in period clothing, giving him an old-world look. You may choose more contemporary clothing. Either way, pay attention to the width of the neck, noting that the two lines connect at the base of the chin and at the earlobe.

6 Add Hair Details
Add more detail to the basic hair structure. My character's hair is loosely parted to one side, so most of the lines emanate from an area on one side of his forehead. Curving some strands in slightly different directions can liven up both the hairstyle and the drawing.

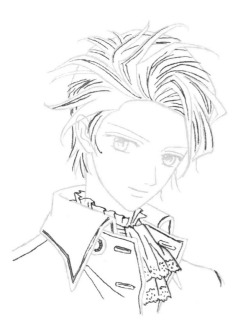

7 Add More Details to the Hair and Clothes
Time to add further details to the hair and to the clothing. I consulted photos of old formal wear for ideas on how to add ruffles and other bits of trim. But again, make the drawing your own. If you think he'd look better in a hoodie, then go for it!

8 Ink the Drawing
Now get your pen, and ink all the lines. Shojo inking tends to be delicate and graceful, so take your time and don't rush it. Once you're done, let the ink dry, then erase all the pencil lines. Between this drawing and the last one, you've taken on two noticeably different styles already. But just you wait; many more styles lie ahead.

Dark Fantasy

The Japanese are masters of making things cute, but when they want to, they can go to the dark side as well. This time we'll learn some methods for drawing a decidedly different character: a goth-ish girl whose favorite color is jet black and who wouldn't be caught dead with flowers in her hair. Yes, our sense of her personality is partly derived from her clothing and her cold-as-ice facial expression. But just as important are the principles of design that stand behind the drawing: the sharp angles and the rigid lines.

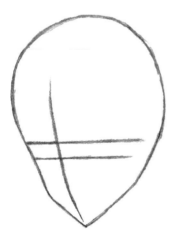

1 Mark the Head Guidelines
Begin with the basic shape of the head. It's taller than it is wide and comes to a sharp point at the chin. The lines for the eyes are close together, and they fall well short of being halfway between the chin and the top of the head. Since she's facing to the left, the vertical nose-and-mouth line is also on the left.

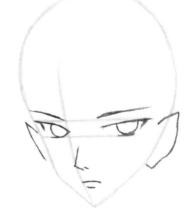

2 Draw the Basic Features
Add basic lines for the eyes, eyebrows, nose, mouth and ears. Note how I've made every angle sharp and pointy rather than gently rounded. I even made the ears pointed! The goal is to convey harshness in the facial features and thereby make her personality seem harsh as well.

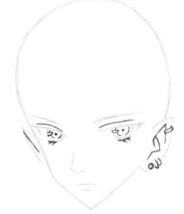

3 Add Details to the Features
Now it's time for more details in the eyes and ears. I chose to give each eye a single little sliver of highlight and to contract the pupils down into tiny dots to give her a distant, spooky stare. And any proper goth girl would want her fair share of earrings, so I certainly didn't hold back in that department.

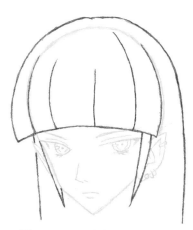
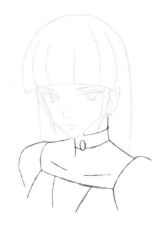
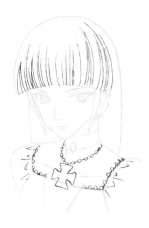

4 Draw the Hair

As always, feel free to be creative with the hair. I opted for super-straight lines without the slightest hint of waviness and bangs cut absolutely clean across. Finally I placed two fanglike strands of hair at the ears, framing her face and adding a couple more sharp angles to the general prickliness.

5 Draw the Neck and Shoulders

Now turn to the neck and shoulders and put in some basic lines for her clothes. Note the width of the neck; always an important part of conveying femininity. Clothing always says a lot about a character's personality. A choker at the neck is a great way of making a character seem disciplined and thoroughly under control.

6 Add Details to the Hair and Clothes

With the main contours in place, begin adding details. The lines of the hair gradually curve to the left and right, revealing the shape of the head beneath. I decided to add an ornate necklace as well as trim and wrinkles along the edges of the dress, but feel free to do things differently; it's your character, and you're in charge.

7 Continue Adding Details

You're nearly done now. All that's needed is a bit more detail for the hair and the clothing. As a challenge for myself, I went for a detailed pattern on the choker. With line work like this, you can consult photos of actual clothing or just invent new patterns of your own.

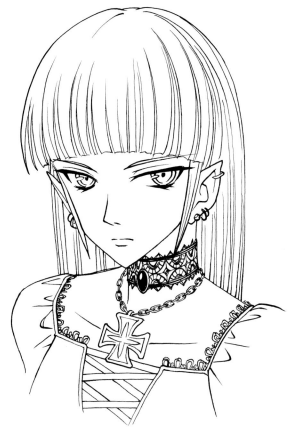

8 Ink the Drawing

Switch from pencil to pen, and ink all the lines. Do your best to ink each line of the hair with a single stroke. Allow plenty of time for the ink to dry, then erase all the pencil lines. Nicely done: Only three lessons in, and you've already taken on three vastly different styles.

Shonen Realism

Say the word "manga" and most people will think of cartoony characters with gigantic, shiny eyes. But a great many Japanese artists choose to create stories with much more realistic-looking drawings, making books that are nevertheless instantly recognizable as real manga. In this lesson we'll take on the challenge of drawing in one such style. It falls within the realm of *shonen* comics: manga geared more toward a male readership and typically featuring tough guys, fight scenes and plenty of action.

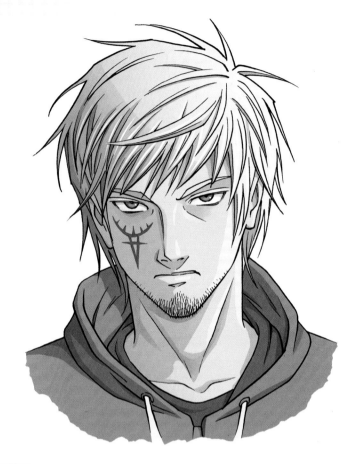

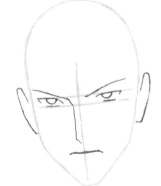

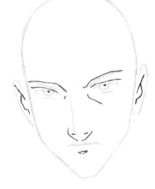

1 Mark the Head Guidelines
Start as always with the basic shape of the head. In keeping with real human anatomy, this head is much taller than it is wide. Note the angled lines of the jaw and the somewhat squared-off chin. The lines for the eyes are very narrowly spaced, and they fall right around the halfway point between the chin and the top of the head.

2 Draw the Basic Features
Time to add the eyes, eyebrows, nose, mouth and ears. One good rule of thumb for realistic anatomy is to have one eye's worth of space between the two eyes. The mouth is a good bit closer to the nose than to the chin. And the ears start at the tops of the eyebrows and stop near the bottom of the nose.

3 Add Details to the Features
As you might expect, a realistic style includes facial details that were omitted in the other lessons, especially in the area of the nose. Add lines to thicken up the eyebrows, and drop in a small shadow beneath the lower lip. See the lines inside the ears? They're not so complex, but they do a good job of conveying realistic ear structure.

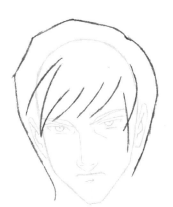 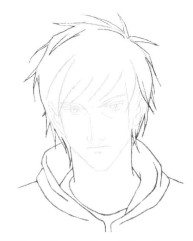

4 Draw the Hair

Now we can draw basic guidelines for the hair. I've chosen to have the hair loosely parted on the right, so all the lines are flowing to the left. Note though how they still curve, as in earlier lessons, to suggest the surface of the scalp beneath. Feel free to change things up and alter this hairstyle to suit your own tastes.

5 Draw the Neck and Hoodie

I thought a hoodie would fit nicely with this fellow's look, but you might go for something more formal. Either way, pay attention to the size of the neck. Approximating real human anatomy, it's much wider than the other necks we've drawn so far. Let's add extra strands along the contours of the hair.

6 Add Hair Details

A realistic character needs realistic hair, and that means adding more strands and paying close attention to how they're placed. I drew most of them flowing in the directions established in step 4, but then dropped in a few stray strands that shoot off on a path all their own.

7 Add More Details to the Face and Clothes

Now comes the fun part: adding final details. I thought a bit of facial hair and an enigmatic tattoo would set this guy apart from the pack. A few final wrinkles in the clothing and our bad-boy character design is complete.

8 Ink the Drawing

Grab your pen, and ink all the lines. Allow plenty of time for the ink to dry, then erase all the pencil work. Now you've drawn four manga faces in four radically different ways. In the lessons ahead we'll take on the challenges of bringing in the upper body and getting further into the details of each character's clothing.

Changing Hairstyles

Nothing defines your character's look more than his or her hairstyle. In fact, you could almost say that changing the hairstyle will change the character's perceived personality. I decided to redraw three of the characters from the preceding lessons, giving each of them a drastically different hairstyle. Compare them to their earlier versions to see if you agree with me that they nearly look like different people altogether.

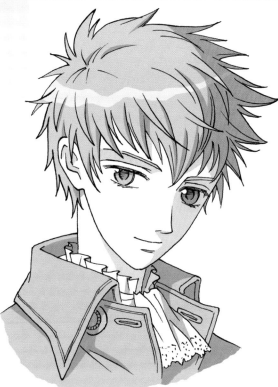

Short and Spiky

Here we see what happens when gentle, soft-looking hair is made to appear more spiked and punkish. In the earlier version he seemed quite elegant and dolled up, like he had just spent quite a while in front of the mirror. Now he seems more of a maverick to me. A rebellious artist perhaps? Changing the hair truly does change the man, it would seem!

Lightening Up the Goth Girl

This little makeover results in a change even more dramatic. In the earlier version the character's long straight hair made her seem very severe and almost a little threatening. Now, without altering her facial expression in the slightest, she seems more approachable and relaxed. Why? It's all in the hair, surely. Something about those curving lines has caused her to loosen up a little.

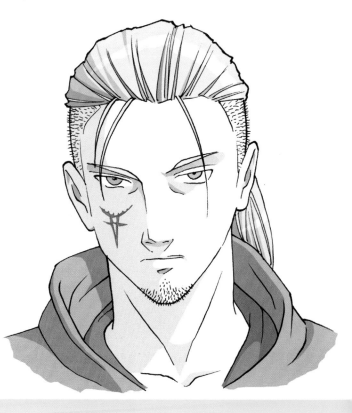

From Tough to Tougher

Let's face it: Even in the earlier version this fellow did not come across as a very nice guy. But this new version takes things to a different level. A man with his hair slicked back from his forehead always looks like he means business, so that's part of it. But make his head shaved on the sides and you've got somebody you definitely don't want to have as an enemy.

Inventing a Hairstyle

Many of these lessons include hair as part of what's being taught, so you'll get a lot of practice drawing various hairstyles as you work your way through this book. But here I want to show you how an artist thinks of the fundamental structure of a hairstyle. By understanding the big basic building blocks underneath all those flowing lines, you can get a better idea of how to invent a new hairstyle on your own.

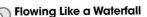

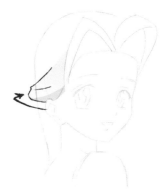

1 Visualizing the Waves
To follow along with this lesson, begin with the basic guidelines of the Shojo Cuteness demo character minus the hair. Now try to visualize the construction of a new hairstyle starting with two waves of hair parted in the middle of the forehead. Both of these structures will extend in length later on, but for now let's move on to the next part of the hairstyle.

2 Flowing Like a Waterfall
Imagine the rest of the hair flowing down off the top of the head, down past the base of the neck. Don't think of individual strands of hair. Just try to get the big picture.

3 Pulled Back From the Temples
Envision two separate sections of hair pulled back from the temples and clasped together at the back of the head. This will give our character an elegant look.

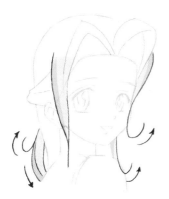

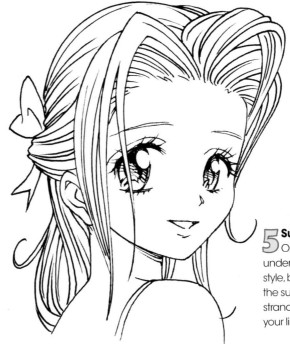

4 Waves and Curls
Now extend the parted strands down on either side. If you like, make them curl a bit at the tips. Feel free to play around with many versions at this stage: long, short, straight, curly and so on.

5 Surface Details
Once you know the underlying structure of a hairstyle, begin to visualize each of the subsections into individual strands. Finalize details and ink your lines to finish.

Cartoon Simplicity

Since we're taking on the challenge of drawing a good bit more of the human figure this time, let's start with something that's not too difficult: A cartoony style that you might find in a manga meant for younger readers. Every aspect of the anatomy has been simplified, and the emphasis is on fun rather than strict realism. This doesn't mean that it can't be taken seriously though. Indeed, every style has its own virtues and its own limitations, and you may find that a highly stylized approach is the one you like best.

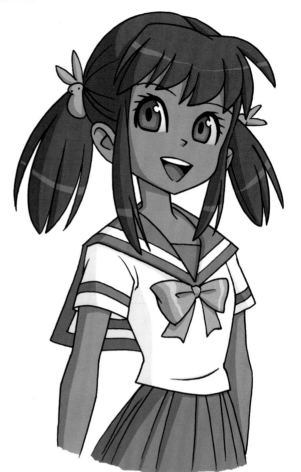

1 Mark the Head Guidelines
Let's start with the basic guidelines of the head. The youth of the character calls for a babyish head shape, one that is only slightly taller than it is wide. The eye lines are widely spaced, and the higher of the two is almost exactly halfway between the chin and the top of the head.

2 Draw the Basic Features
Now let's go for the facial features. The irises are oval-shaped, but flattened at the bottom to suggest a lower eyelid. As always, pay attention to the blank spaces including the distance from the nose to each eye and the space between the mouth and the chin. The ears are very low on the head, a common cartoony choice that creates more space for the hair.

3 Draw the Hair and Add Details to the Features
It helps to build up the hairstyle with some basic guidelines before getting into the details. I've chosen a pig-tailed hairdo to accentuate the youth of the character, but you might want to try something different. By adding some structural lines to the ears, plus eyelashes and highlights to the eyes, you can complete the facial features.

4 Add Details to the Hair

Once you know the hairstyle's basic contours you can move on to drawing individual strands. Lines fanning out on the side of the head can help convey the structure of a pigtailed hairstyle like this one. Adding a unique accessory, like these little bunnies in her hair, can help make a character more distinctive and recognizable.

5 Draw the Body Contours

Note the angle, placement and especially the width of the neck. It's much narrower than the ones we drew earlier. The angle and width of the shoulders are barely wider than the head, making us see her as a child rather than a grownup.

6 Draw the Clothing

With the body in place we can begin adding lines for the clothes. I've opted for a traditional Japanese sailor suit school uniform, but you may want to try something different. No need for details. We want only the basic shapes for now.

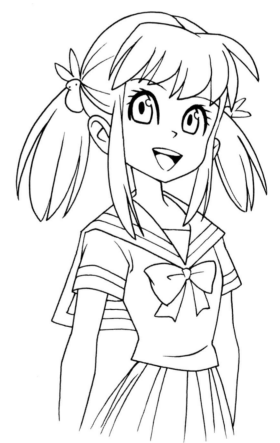

7 Add Details to the Clothing

Real cloth tends to have loads of wrinkles, but our simplified approach allows us to get away with just a single line at the waist and a couple of lines near the shoulder. Even the ribbon is greatly simplified—a cartoon ribbon rather than a real one. Add a few pleats on the skirt, fanning out from the waist, and you're done.

8 Ink the Drawing

Switch from pencil to pen, and ink all the lines. Do your best to draw every line with a single stroke of the pen; it's the best way to get a smooth, professional look. Allow time for the ink to dry, then carefully erase all the pencil lines. So there you have the simple approach. For something a bit more challenging, just turn the page.

Adding Details

Part of the fun of character creation is coming up with a character's look. Choosing the clothing, hairstyles and other items associated with your characters is what allows you to make them distinctive and unforgettable. In this lesson we'll go beyond drawing a generic manga guy and make the leap to rendering a specific character, one who looks like he has just stepped from the pages of his own story.

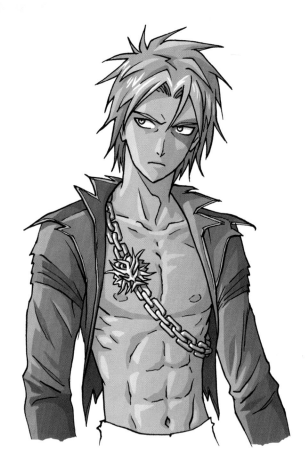

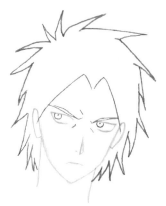

1 Mark the Head Guidelines
Since this character's anatomy is fairly close to real human anatomy, we'll need to make the head considerably taller than it is wide, tapering a bit as it reaches the chin. The guidelines for the eyes are very narrowly spaced, the higher of the two falling nearly halfway between the chin and the top of the head.

2 Draw the Basic Features
Next let's add the basic guidelines of the facial features and the neck. Leave close to an eye's width of distance between the eyes, and make sure the mouth is just slightly closer to the nose than to the chin. Observing the two points where the neck lines connect to the head will help you get the proper width of the neck.

3 Draw the Hair and Add Details to the Features
Draw the contour of the hair. This character's hair parts in two places: down the middle in front and on the left in the back. No two strands of hair point in the exact same direction, and each is of a slightly different length and size. Add the eyebrows and irises, drawing the brows down over his eyes for an angry scowl.

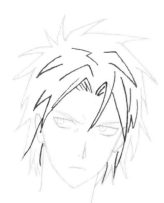

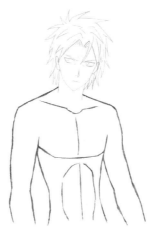

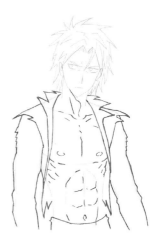

4 Add Hair Details

Once the basic hair outlines are in place, add strands and other details to the hair. At the part in the center of the forehead, try adding short, tightly packed lines that show how the hair connects to the scalp. To keep things natural looking, I chose to add a single stray strand of hair down between his eyes.

5 Draw the Body

Before drawing clothing it's a good idea to get down the basic lines of the body. Be careful about the angle of the shoulders and the point at which they join the lines of the neck. Note the width of the arms and the way the chest muscles are structured around a central vertical line up the middle.

6 Draw the Clothing

Now for the clothing. I chose to make his jacket have a distinctive jagged collar, but feel free to invent clothing all your own. The guidelines from the previous step will help you add details to the musculature. I prefer subtlety in this area: short lines that hint at the muscles rather than longer lines that define them with unnatural clarity.

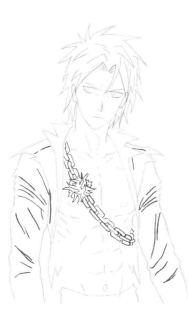

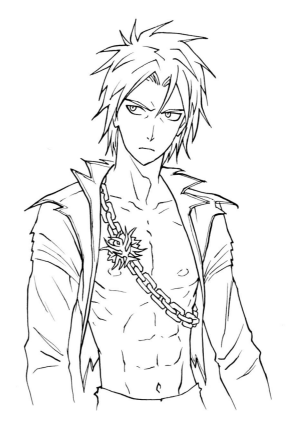

7 Add the Clothing Details

Characters from manga stories often have very distinctive costuming. I've given this guy a mysterious chest chain to set him apart and add visual interest. Why not invent a different item? Use your imagination and devise something that suits your own tastes. Add wrinkles to complete the clothing.

8 Ink the Drawing

Now you can switch to your pen, and ink all the lines. Allow drying time for the ink, then erase all the pencil lines. Nicely done. You haven't simply completed a drawing, you've learned a thing or two about character design.

Uniformed Characters

One of the time-tested methods of making manga characters visually interesting is to give them uniforms. From high school romances to gritty warfare sagas, characters in uniform immediately stand apart from the everyday world of people wearing T-shirts and jeans.

In this lesson we'll draw a classic anime maid character, learning how to draw the details of her clothing and giving some thought to her personality as well.

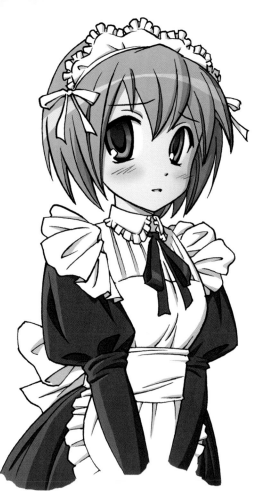

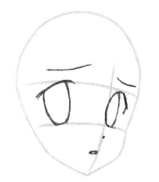

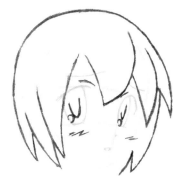

1 Mark the Head Guidelines
This head shape is just a little taller than it is wide, and the angle of the chin isn't super pointy. The guidelines for the eyes are very widely spaced, and the higher of the two lines is a touch closer to the top of the head than to the chin.

2 Draw the Basic Features
In this style the eyes are quite large and very far from each other. The three-quarter point of view results in a more compact eye on the right than on the left. This character is shy, so I made her eyebrows curve upward to convey a look of uncertainty.

3 Add Hair and the Eye Details
For this uncomplicated hairstyle, the strands flow across the scalp, curving to the left and right, all of them pointing more or less straight down. Add a few key details to each eye: small highlights on the lower left, a U-shaped indication of the pupil and a short line for the fold of the eyelid.

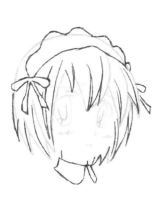

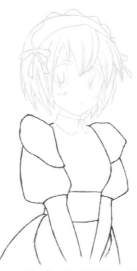

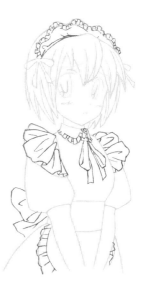

4 Add a Head Covering, Collar and Hair Details

Japanese maid characters generally have some sort of head covering, so I've put in the basic lines of one, wavy on the top with little ribbons on both sides. The neck is quite narrow, and I've added a collar seen from a three-quarter view just as her head is. If the hair still looks unfinished to you, add more lines as I have here.

5 Draw the Basic Clothing Guide-lines

In cartoony styles you can sometimes move past the anatomy and just go straight to the clothing. Here you see the basic guidelines of a classic French maid costume in a pose that conveys a certain insecurity. As always, feel free to change the clothing to suit your own tastes.

6 Add the Clothing Details

I added a lot of detail to the clothing, but you can go for a simpler look if you prefer. The ribbon around her neck and the ribbon at the back of her dress could be left out entirely. See how I've repeated certain elements throughout the design? The idea is to make it all come together into a unified whole.

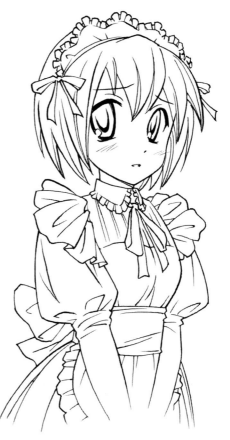

7 Add the Clothing Wrinkles

When it comes to adding clothing wrinkles, the degree of detail I've used here is optional. Just a few wrinkles here and there can be just as effective. Note that in the area of the waist and the elbows the wrinkles are horizontal, while elsewhere they are mostly vertical.

8 Ink the Drawing

Switch from pencil to pen, and ink all the lines. Allow some time for the ink to dry, then erase all the pencil lines. Here we've looked at a popular type of uniform that is attractive and cute. In the next lesson we'll turn to one that is rather more serious, but no less popular in the world of manga and anime.

Military Characters

Some of the most popular manga series from recent years have included military uniforms as a significant part of the world-building. Stories ranging from *Fullmetal Alchemist* to *Attack on Titan* have featured men and women in uniform among their most important characters. If you are creating a similar story, you'll want to begin training yourself to draw uniforms in a convincing way.

In this lesson we'll draw an older character, studying the techniques artists use to show that a person is in a later stage of life than the fresh-faced youths surrounding them. For example, people with facial features high on the face invariably appear older than those with the same features drawn lower on the face.

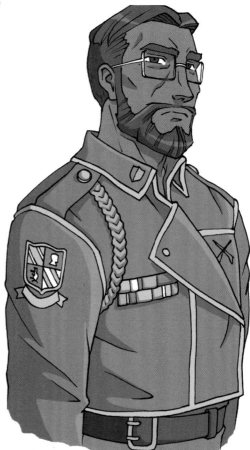

1 Mark the Head Guidelines
This head shape is very different from those we've looked at so far. The jaw and the cheekbone are sharply angled. The guidelines for the eyes are extremely close together and closer to the top of the head than to the chin.

2 Draw the Basic Features
Draw basic guidelines for the eyes, nose, mouth and ear. The small size of the eyes is another trick for making a character look older, as is making the bridge of the nose long and clearly outlined. I've added a beard, but feel free to skip that part if you want to simplify things.

3 Add Details to the Features
Move on to the details of the face: wrinkles around the eyes, musculature on the neck and structural lines on the forehead. Note that this is the first time we've seen the nostril clearly defined. This is yet another way of showing age. The glasses are a choice I made but not essential.

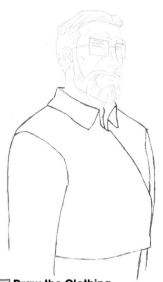
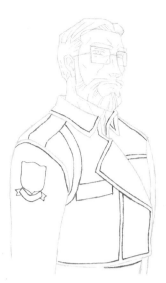

4 Draw the Hair and Beard

As always, it's important to have a plan for the structure of the hair and then to use lines to convey that structure. I opted for a trim, controlled look to go with his military position. Note how the lines on the beard curve to illustrate the form, helping your eye to see the structure.

5 Draw the Clothing

Time to put in some basic guidelines for the uniform. Pay attention to the slope of the shoulders as well as their width. They are about three heads' width from one side to the other.

6 Add the Clothing Details

Now move on to the fun part of designing the specifics. I studied photos of real military uniforms for ideas, but you may go for something more in the realm of fantasy. The key is consistency: If one part has trim, it's likely that trim would repeat throughout the design in a real uniform.

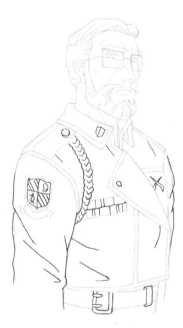

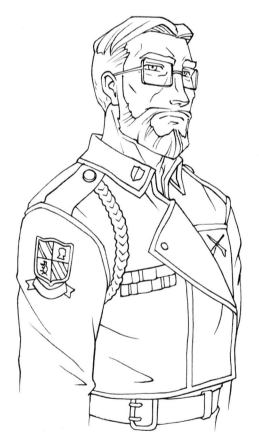

7 Add the Final Details

Add a few wrinkles to the cloth. The patch on the arm could be a random design, or it could relate to something else in your story. Part of the fun is working out the final touches and making them your own.

8 Ink the Drawing

Now you can take your pen, and ink all the lines. Allow plenty of time for the ink to dry, then erase the pencil lines. Remember that these methods for conveying age can be applied to any character, not just those in uniform. Any time you're drawing an older character, you may want to come back to this lesson for another look at the tricks of the trade.

Shojo Realism

In an earlier lesson we looked at one of the more realistic-looking manga styles, a tough guy from the shonen side of things. This time let's see how a shojo artist might make use of a realistic style. Interestingly, it's not so much about piling on loads of detail. It's more a matter of trying to stay true to human anatomy and avoiding exaggerated proportions.

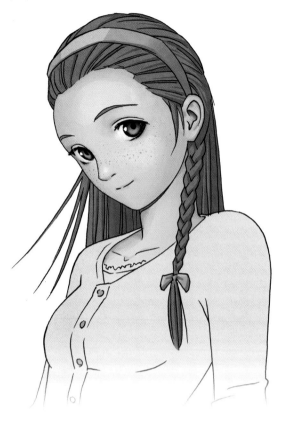

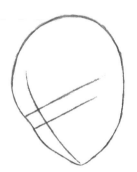

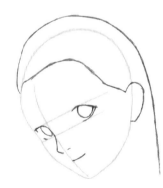

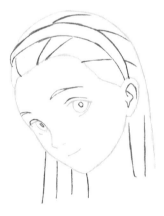

1 Mark the Head Guidelines

The head shape is somewhat child-like, taller than wide but not by a huge margin. Note the subtlety in the contour of the cheek. Every minor curve needs to be just so. The guidelines for the eyes are closer together than in a typical shojo drawing, with the higher of the two lines falling halfway between the chin and the top of the head.

2 Draw the Basic Features

Now let's move on to the basic guidelines for the facial features and the hair. Her eyes are quite widely spaced, conveying a sense of inno-cence. The irises are perfectly round rather than oval shaped. The bridge of the nose is clearly defined, something you won't see in the vast majority of shojo illustrations.

3 Add Details to the Features and Draw the Hair

Only a few more details are needed for the face: eyebrows, a good distance up on the forehead, plus pupils and eyelid folds for each eye. The ear structure here is quite accurate to real human anatomy. Note how the lines of the hair fan out from her forehead, curving to reveal the shape of her scalp beneath.

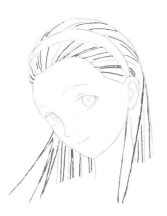
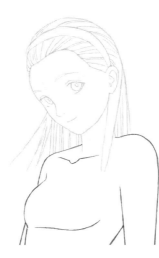
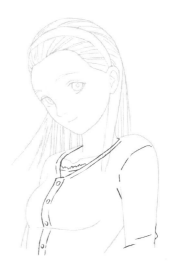

4 Add Hair Details

This stage is all about adding detail to the hair. The basic hair lines from the previous step determine the direction of each new line added here. I've chosen to give this girl a braid back behind her ear, but you may choose a different location or dispense with the idea altogether.

5 Draw the Body

In the less cartoony styles it's important to establish the anatomy prior to drawing the clothes. Pay close attention to the points where the shoulder lines join the neck—if they are too high up, her neck will seem too short. Note also the width of her upper arm and the placement of her collarbone, shifted to the left as she turns away from us.

6 Draw the Clothing

Now you draw the clothing. As always, think about the pose of the body before adding any lines. The collar of her sweater shifts to the left, lining up with the collarbone above it. A seam along the shoulder is a nice detail that allows us to see the form of her shoulder underneath it.

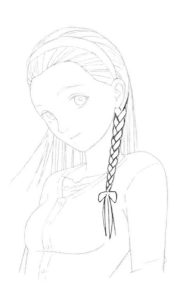

7 Add a Braid

If you want to include a braid, now's the step for devoting your attention to it. In *Mastering Manga 2* there's a step-by-step lesson devoted to this, but close study of photos can also help you understand the interlocking pattern of a braid. Note that the structure gets gradually smaller from top to bottom.

8 Ink the Drawing

Switch from pencil to pen, and ink all the lines. Take a break and let the ink dry, then erase all the pencil lines. By now you've explored a pretty wide range of manga styles, but most of the characters so far have stayed within the realm of ordinary human beings. In the lessons ahead we'll begin stepping more decisively into the world of sci-fi and fantasy.

Sci-Fi Characters

Manga stories can be great for capturing ordinary life, but surely they are better known for taking us to imaginary worlds, showing us amazing things that exist only within their pages. In this lesson we'll have a look at a sci-fi character and learn a thing or two about designing futuristic costumes. The subject presents some challenges to be sure, but I always feel liberated when drawing imaginary things. If it doesn't exist in the real world, I figure I'm free to draw it any way I please.

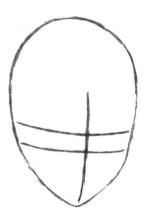

1 Mark the Head Guidelines
This head shape is quite close to human anatomy, but the placement of the eyes is somewhat stylized. The guidelines for the eyes are a bit more widely spaced than would be needed for anatomical accuracy. They are also quite low on the head, helping to create a sense of youthfulness.

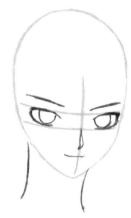

2 Draw the Basic Features
Now you can add the neck and the basic facial features. There is almost exactly one eye's width of space between the two eyes, and the irises are perfectly round. The mouth is closer to the nose than to the chin. The neck is a bit thicker than you might expect, in anticipation of the costuming yet to come.

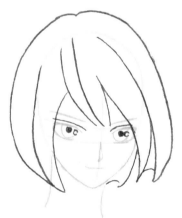

3 Draw the Hair and Eye Details
Here we can get in a few more details for the eyes: pupils, small highlights and the folds of the eyelids. Then we can place the basic guidelines of the hair. I've imagined it loosely parted on the left with most of the lines flowing down from that area. As always, feel free to invent an entirely different hairstyle if you like.

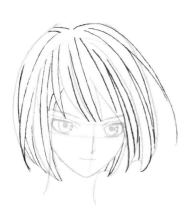 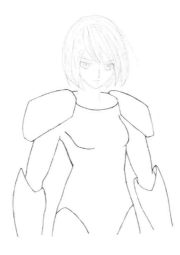 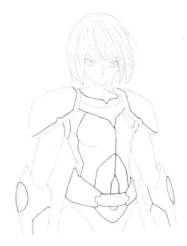

4 Add Hair Details

Once the basic hair guidelines are in place you can add more strands of hair all across her head. The pattern is fairly regular, curving to the left and right as it often does. But notice how I've added some stray hairs here and there—hairs that go off in a slightly different direction—to give the hair a more natural look.

5 Draw the Body and Costume Contours

You may choose to draw a bit more of the anatomy to get started, but I've opted for a combined approach: body contours in the area of the torso, and costume contours in the areas of the shoulders and forearms. If you have a different ideas for the shoulder pad shapes, go for it.

6 Add the Costume Details

Now for the fun part: working out the costume design. To get the perspective right and balance the structure, it helps to have a central vertical line running up the middle of the torso. I've opted for a form-fitting belt, but you may prefer something with more mass to it. Note that every curving line follows the surface of the form beneath it.

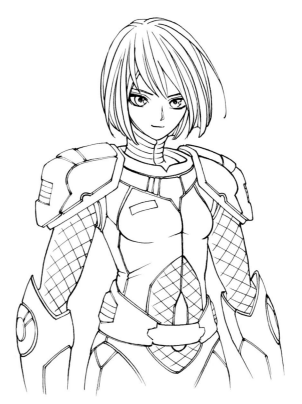

7 Add the Final Details

As always, I've saved the finer details for last. I chose a fishnet pattern for part of the costume, curving the lines to convey form. My design is mostly symmetrical, but you might opt for a less standardized approach. Half the fun of doing sci-fi illustrations is playing around with different possibilities.

8 Ink the Drawing

Time to switch to pen so you can ink all the lines. Leave plenty of time for the ink to dry, then erase all the pencil lines.

I've stuck with a conventional human look for the characters in every lesson so far. But nonhumans can be characters too. Indeed, they often prove to be the most popular characters of all.

Nonhuman Characters

If you really want to stretch your creative muscles, then dreaming up a nonhuman character is just the job for you. Untethered by the laws of human anatomy, you are completely free to push your design in any direction you choose. In this lesson we'll create an alien-type character who'd be right at home in an old-school shonen manga series. To make sure he's distinctive and memorable, we'll give him a very specific look, one that suggests a long and interesting backstory.

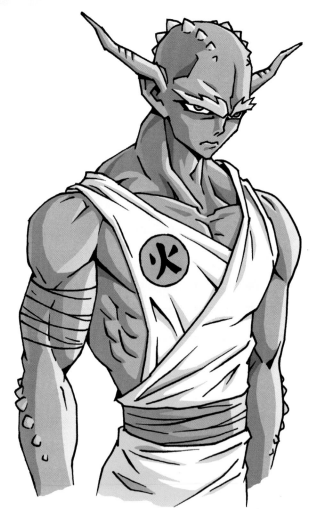

1 Mark the Head Guidelines
Though our character will have many nonhuman features, we still want a basic humanoid structure underneath it all. The head shape is fairly conventional though more angular than those in previous lessons. As always, note the distance between the guidelines for the eyes—quite narrow in this case—and the fact that they are closer to the chin than to the top of the head.

2 Draw the Basic Features
The facial features can have any characteristics you choose. I've opted for squinty eyes, outlined on all sides, with irises tucked up under the upper eyelids. This creates a look of strength and defiance. My way of drawing the nose and mouth is merely a suggestion. It's your character, so make it your own.

3 Draw the Ears and Eyebrows
Here's where we really get into the nonhuman part of the character. You are free to draw any type of ears you want. I decided to make them pointed and hornlike. Bushy eyebrows are certainly not the norm for most manga characters, but, hey, this guy is all about not being the norm!

4 Draw the Neck and Head Spikes

Now draw the structure of the neck. As with many alien designs, it has its roots in actual human anatomy but is pushing it in different directions. I thought two rows of spikes along either side of his scalp would be an interesting feature, but you may come up with something more daring.

5 Draw the Body

For the body, let's start with some basic guidelines and save the details for later. Note the bulk and breadth of the shoulders: They have more than three heads' worth of width from side to side. Drawing a collarbone always helps to convey the structure of the chest.

6 Draw the Clothing and Muscles

Time to add clothing and lines that bring definition to the muscles. Happily you don't have to think too much about human anatomy, as this character isn't human. Still, it helps to imagine the surface of the muscles and draw lines that stretch across that surface in a natural way.

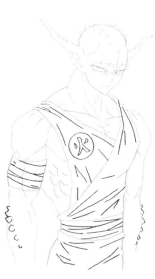

7 Add the Clothing Details

I chose to give him clothing that has a lot of wrinkles. Note how the direction of the wrinkle lines is determined by the clothing's path across his chest and around his waist. I also repeated the head spike feature on his forearms to tie the design together.

8 Ink the Drawing

Almost done. Grab a pen, and ink all the lines. Allow plenty of time for the ink to dry, then erase the pencil lines. You can consider the drawing finished as is or add color if you like.

Character Consistency

One thing that many aspiring manga artists struggle with is the inability to keep a character looking the same from one panel to the next. If you suffer from this problem you may find that every time you draw your character he or she looks slightly different, sometimes drastically so. Here are some tips for keeping your characters consistent in appearance.

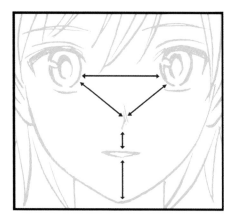

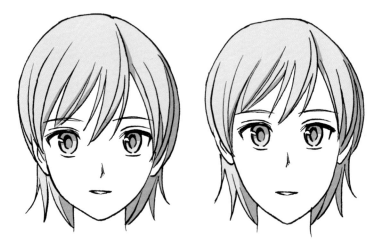

Spacial Relationships

The most important requirement of character consistency is making sure your character's facial features are in the same places relative to one another. For me the key is to pay attention to the distances between the eyes, nose, mouth and chin. As an artist you need to establish a pattern for all these distances and stick with that pattern every time you draw the character.

Spotting Inconsistency

Compare these two drawings. The eyes, nose and mouth are identical, but the spatial relationship between them has changed. In the second picture the nose is higher and the eyes are closer together. As a result they don't look like quite the same person.

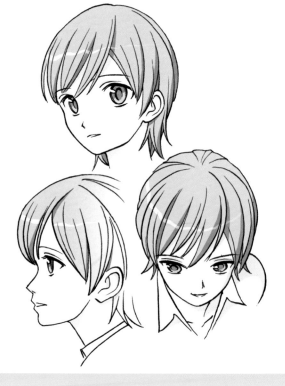

Practice Makes Perfect

Even before you begin working on a manga story, you should practice drawing all its main characters from a variety of angles. *Mastering Manga* books 1 and 2 contain lessons showing how to draw the various angles you see here. You can also learn a lot about character consistency by studying the illustrations found in professionally published manga. Analyze the spacial relationships between the various facial features and see how the artists maintain those relationships consistently page after page.

Spot the Differences

You can't eliminate inconsistencies until you can see inconsistencies. It can be especially difficult to notice the blank spaces between different facial features, yet that is often where the problem lies. Here are three side-by-side drawings in which I have deliberately included inconsistencies. Can you spot them? Find the answers at the bottom of the page!

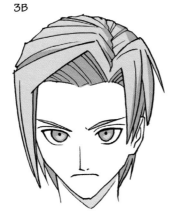

1A 1B 2A 2B

3A 3B

Using Your Eagle Eye

This is more than just a game. By learning to see the inconsistencies in these drawings, you are training yourself to spot similar errors in your own work later on. Over time you will gain a reflexive instinct for memorizing facial structures and reproducing them consistently from one drawing to the next.

ANSWERS

1. The chin in 1B is larger than the chin in 1A.

2. The nose in 2B is higher than the nose in 2A. The eyes in 2B are more widely spaced than the eyes in 2A.

3. The forehead is larger in 3B than in 3A. The eyes are closer together in 3B than they are in 3A. The mouth in 3B is closer to the nose than it is in 3A.

Cartoony Animals

When we think of manga characters we tend to think of characters that are human or at least something like a human. But many stories devote a supporting role to an animal of some kind. Maybe it's the protagonist's pet or the bad guy's little helper. It could be a minor character that pops up in a single scene or a pivotal one that's part of the plot from beginning to end. Either way, being able to draw animals is a very useful skill to have when it comes to creating a manga story.

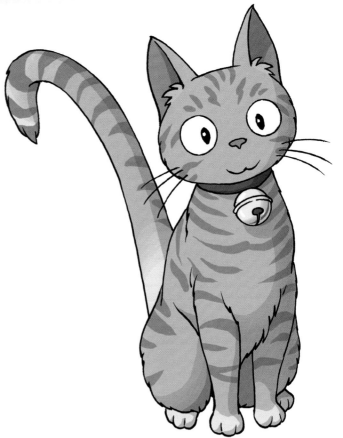

1 Mark the Head Guidelines
In this first lesson we'll be drawing a cartoony cat, the sort you might see in an anime film. Since the anatomy is not meant to be realistic, the head shape becomes a simple oval. Note, though, that I've tilted it a little to one side to make the final pose a little more lively.

2 Draw the Basic Features
Now it's time to draw the facial features. The eyes are really just big circles at this stage. Pay attention to the distances between them and the contour of the head. The nose is as high up as the bottom of the eyes, and the mouth is quite close to the bottom of the head.

3 Add the Ears, Irises and a Collar
When adding the ears, think about which proportions you find pleasing to the eye. I've made the ears very large and pointing straight up. You might choose to make them smaller or to have them point out a little to the sides. Making the irises small gives this cat a look of alertness. When drawing the collar, have it curve a bit to reveal the form of the neck beneath.

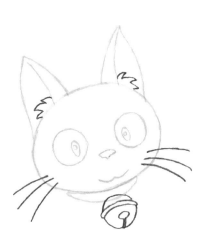
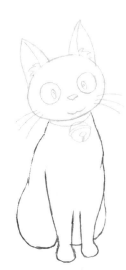
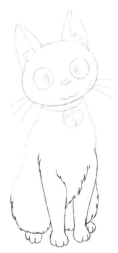

4 Add Ear Fur, Whiskers and a Bell

At this stage we can get into details. Most cats have fur in the area of the ears, so I've worked some in here. I've gone minimal with just three whiskers on each side, but you may opt for more. And, yes, I couldn't resist adding a bell to the collar!

5 Draw the Body Shape

When drawing the body shape, note that it is equal to about three of the heads in height. The rear legs are mostly concealed by the body, so your main job at this stage is to focus on the front legs. Pay attention to both their length and their width, especially near the paws.

6 Add Fur and the Rear Paws

Once you have the body shape in place, you may choose to add fur along the contour as well as above the front legs as I have done here. The rear paws are almost identical to the front paws, all of them being divided into three toes.

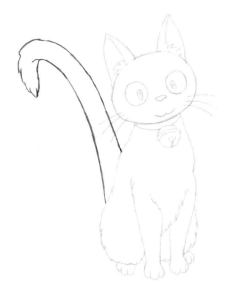

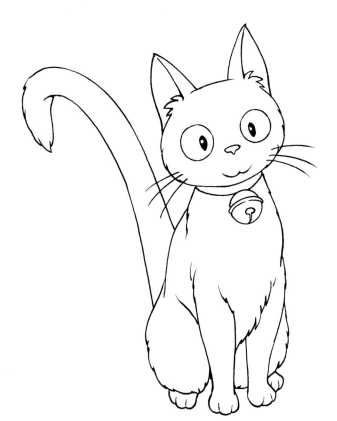

7 Draw the Tail

Well, it's not a finished cat without a tail, is it? Since it is fully flexible, you can draw the tail curling off in any number of directions. In most cases, though, the tail is straight near the body with its biggest curve forming near the tip.

8 Ink the Drawing

Time to take your pen and ink all the lines. Allow plenty of time for the ink to dry, then erase all the pencil lines. Now that we've learned to draw a cat, the next natural animal to learn is a dog. So turn to the next lesson and let's get started.

Realistic Animals

Not every manga artist chooses to depict animals in a cartoony way. A super cartoony animal tends to have a slightly human touch to it, as if it were an animal on the outside but somehow a wisecracking man or woman on the inside. That's not always what you're going for as a storyteller. In this lesson I'll show you how to draw a dog that is just that: a dog, inside and out.

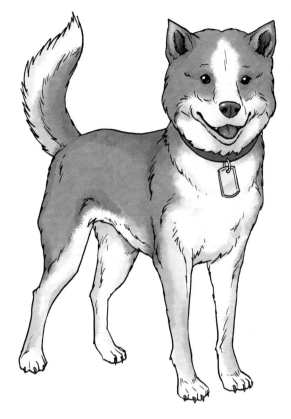

1 Mark the Head and Torso Guidelines
Let's begin with a few rough guidelines for the head, facial features and torso. I've opted for a three-quarter point of view, so that means the body is shifted off to one side. The eyes are relatively high on the head and very widely spaced compared to those of a human.

2 Draw the Legs, Tail and Ears
Add the legs, tail and ears. Note the little crook in the dog's rear legs, a fairly common trait in the animal kingdom. Though of course some dogs have floppy ears that hang down, I've chosen a pair that is a bit more foxlike, pointing up and outward with a bit of a diagonal tilt.

3 Finalize the Furry Contour
In this step I've confined myself to finalizing the dog's furry contour and to adding a collar at the neck. Some areas have more fur such as the tail and the lower part of the head. The line across the back suggests that the fur in that area is relatively short.

4 Add Details to the Face

Time to get into the details of the face. I've put in a sort of loose dividing line across the cheeks to demarcate where light fur near the mouth gives way to darker fur farther away. The nose is slightly triangular in shape with the nostrils on the lower edges. I couldn't resist adding a dog tag just for fun.

5 Add More Fur Details

A few more indications of fur is all the rest of the body needs. Note that these lines serve a dual purpose: conveying the texture of the fur but also in many cases showing the structure of the body beneath.

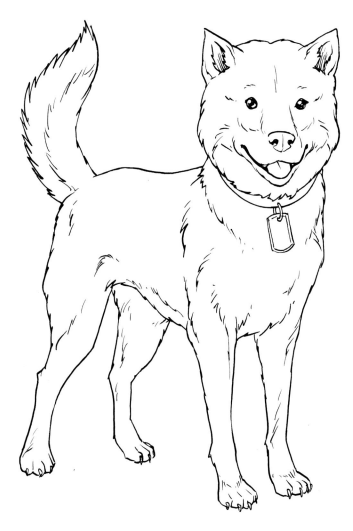

6 Ink the Drawing

You know the drill: Grab that pen and ink those lines. For me, inking a drawing of a furry animal can actually be fairly relaxing. Your lines don't need to be smooth and flawless. You can get away with the jagged irregularity of a zigzagging line. Allow time for the ink to dry, then erase the pencil lines to get a look at your finished drawing.

Poses and Action

If your goal is to be a really good manga artist, you will never be satisfied with drawing a bunch of characters just standing there, staring off into space. You want them to seem alive. You want them to be doing things. You want them, sometimes, to look almost like they're leaping off the page.

Well, read on, friends. Because this chapter is all about drawing poses, and in the pages ahead I'll be giving you my very best advice on how to make them bold, memorable and full of vitality.

Learning to Draw Poses

One skill all manga artists need to have is also one of the most difficult to master.

It's the ability to draw natural-looking poses.

In *Mastering Manga* books 1 and 2, I focused on body proportions and other topics related to human anatomy.

There were a few step-by-step lessons showing full-body poses in each book…

…but with *Mastering Manga 3*, I felt I had to go even further.

This time I've set aside an entire chapter for poses.

By devoting more pages to this topic, I can provide not only many more step-by-step lessons…

…but also supply a wide variety of helpful pose-related tips…

…such as how to convey a sense of motion, how to apply different levels of foreshortening…

…and how to get the most out of your action poses.

This chapter also allows me to delve into unusual topics I've never covered before…

…such as how to draw monsters…

…imaginary animals…

…and mecha-style robots.

There's no magical way to become an expert at drawing poses overnight.

But if you follow all the lessons in this chapter…

…you're going to take some big steps in the right direction, I promise you.

Drawing From Life

At the heart of drawing poses well is a familiarity with human anatomy. This doesn't necessarily mean you need to sit down with a stack of textbooks and start memorizing every muscle and tendon. Indeed, you can learn a lot just by looking at people in the world around you.

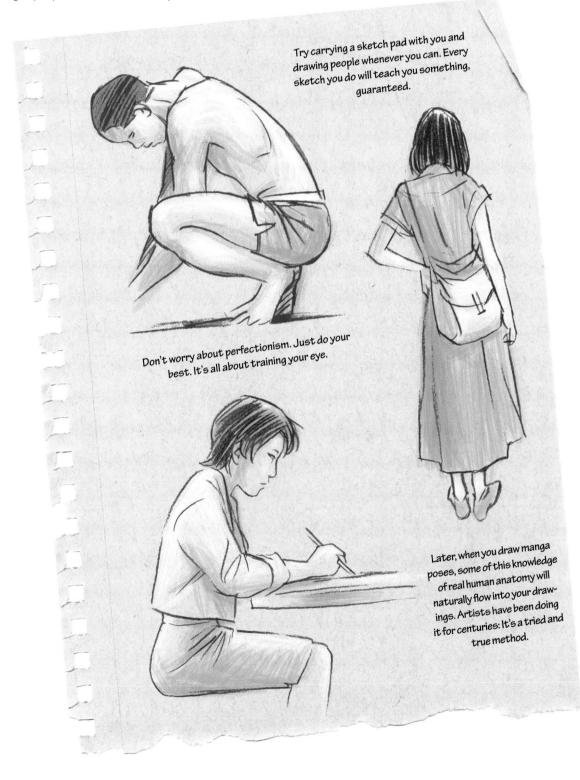

Try carrying a sketch pad with you and drawing people whenever you can. Every sketch you do will teach you something, guaranteed.

Don't worry about perfectionism. Just do your best. It's all about training your eye.

Later, when you draw manga poses, some of this knowledge of real human anatomy will naturally flow into your drawings. Artists have been doing it for centuries: It's a tried and true method.

Energetic Poses

For our first lesson on drawing a full head-to-toe pose, I thought we should look at a classic staple of manga illustration: the cute, energetic female protagonist. Every artist approaches such a character in his or her own way, but the goal is usually similar. She should be charming, full of personality and presented in poses that have a strong sense of movement.

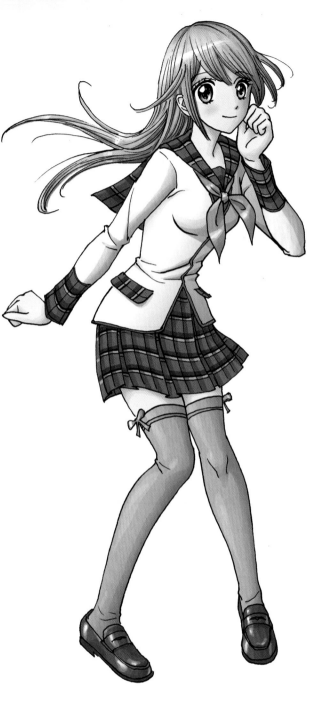

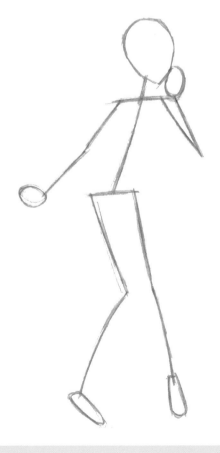

1 Draw a Stick Figure

The first step in all of these lessons will be to draw a basic stick figure, upon which we can build the rest of the figure. It's crucial that the proportions be accurate at this stage, so take your time. Note the length of the legs and arms, the angle of the spine and the size of the head compared to the shoulders.

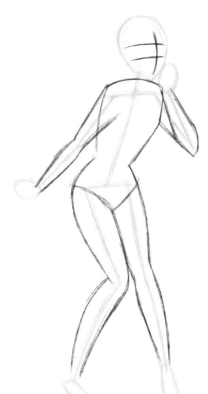

2 Flesh Out the Figure and Draw the Face Guidelines

Now it's time to begin fleshing things out a little. No need for perfection, but do your best to replicate the width of the legs and arms as you see them here. The thighs are roughly twice as wide as the legs are at the shins. Don't forget to put guidelines on the face for placing the facial features in the next step.

3 Start the Features, Hair and Clothes

No need for details yet. Keep things a little rough as you work your way toward the final lines. Note that I've already begun sketching in clothing, in this case a plaid and preppy school uniform. I've given her a long, flowing hairstyle, but you may make a different choice. Use the guidelines you drew in the previous step to help you sketch in the eyes, nose and mouth. I've given my character very large eyes, but you may choose to make them smaller if that's the look you prefer.

4 Continue Sketching the Clothing and Shoes

Again, the goal at this stage is to focus on basic forms. If you try to do minute details now, you might get them in the wrong place. Still, simple decisions like the S-shaped hem of the skirt will have a huge impact on the final drawing. Every choice you make now guides you toward the details you'll add later.

5 Finalize the Contour Lines and Add Face Details

Now that you have a good, solid structure in place, you can finalize some of the lines. My approach is to start with the contours and save the interior details for later. I decided to give her a pleated skirt, but the skirt you choose may be different. This is also the point where I begin focusing on the details of the face.

6 Add the Final Details

And so we come to the final details: the hair, the shoes and the plaid patterns of the school uniform. It may be tempting to try drawing these from the start, but in my experience you'll be better off if you save them for after you've worked out the fundamental structure of the pose. Again, feel free to make your details very different from mine.

7 Ink the Drawing

Switch from pencil to pen, and ink all the lines. Allow time for the ink to dry, then erase all the pencil lines. Congratulations! You've drawn a complete head-to-toe pose and have also learned a thing or two about the steps you'll need to take to create other such poses in the future.

Stiff Poses vs. Natural Poses: Female

One of the biggest problems many artists face (myself included) is the tendency to draw poses that look stiff. Sadly there is no magical method for delivering a beautiful relaxed-looking pose every time. Still, there are a number of tricks you can employ to help get away from the rigid mannequin look that we all find in our poses from time to time.

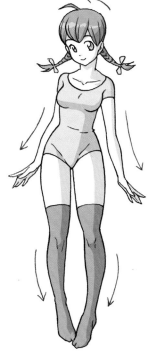

Too Straight

When we imagine a simple standing pose, we tend to think of all the body parts being perfectly vertical: spine, arms, legs, everything. But people just don't stand that way in real life. The woman in this drawing is okay in terms of the anatomy, but she looks like she's strapped to a telephone pole.

Subtle Angles

In this version all the various body parts have a bit of a tilt to them. The bent knee is the most obvious example, but the angles of the neck and elbow also play an important role.

Too Straight

Here we have a different character and a different pose, but the very same problem: Everything's too vertical and as a result she looks frozen and a little lifeless.

Subtle Angles

Again, it's angles to the rescue. By curving her arms outward and her legs inward, we bring life to the pose as well as a little injection of manga cuteness. Next time you draw a standing pose, get a few angles in there and see how they loosen things up.

Standing Poses

Oddly enough, one of the trickiest poses to draw is that of a person simply standing. Or perhaps I should put it this way: It's hard to draw such a pose without the final result looking stiff and unnatural. In this lesson we'll draw a futuristic soldier standing guard with a watchful eye. By completing the steps you'll begin to conquer the surprisingly difficult "just standing there" pose.

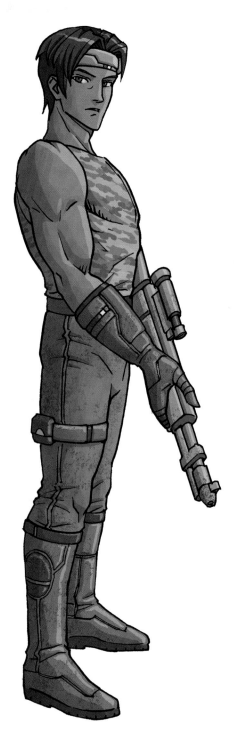

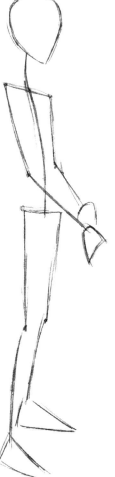

1 Draw a Stick Figure

The stick figure step is probably the most important for it establishes the subtle curve a body takes on when someone is standing in a relaxed way. Note the forward angle of the legs, which is balanced by the backward angle of the spine. The feet point in slightly different directions, a crucial aspect of the pose.

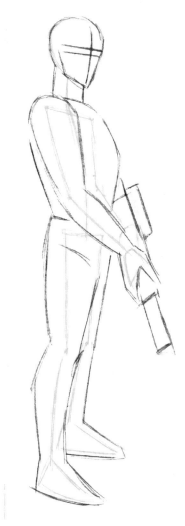

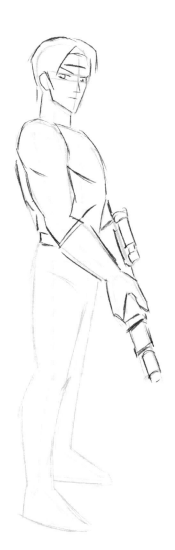

2 Flesh Out the Figure and Draw the Face Guidelines

Since our character is strong and muscle-bound, the arms and legs need to have quite a lot of mass to them. No need to worry about individual details yet. Keep things rough and save the fine-tuning for later. Note the narrow distance between the eye guidelines, leading us toward facial features that will be close to real human anatomy.

3 Start the Features, Hair, Clothes and Rifle

Now you can begin to tighten things up a little. Take your time with the structure of the face, attending to details such as the mouth being closer to the nose than to the chin. I've sketched in some of the musculature and made some decisions about the clothing. The rifle is an imaginary futuristic weapon, so I felt free to invent those details as I went along.

4 Continue Sketching the Clothing and Boots

Turning our attention to the lower part of the body, we can refine the contours of the legs and sketch in the basic structure of the boots. Something like the strap on his thigh is, for me, an aesthetic choice. It adds visual interest to the uniform and makes the character a little more distinctive.

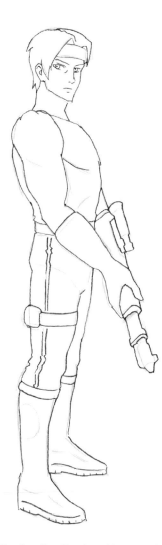

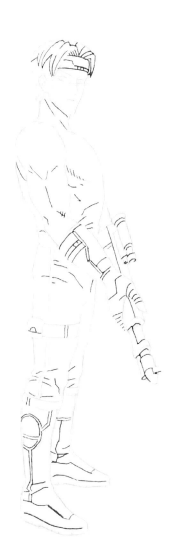

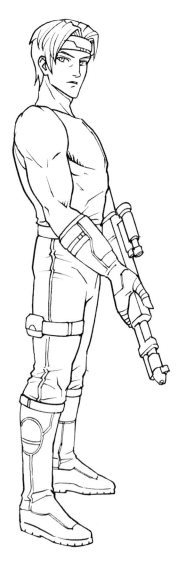

5 Finalize the Contour Lines and Add Face Details

At this stage I'm trying to finalize the contours of the body and finish the details of the face. As always, the hairstyle here is just one of many possible ways to go—longer, shorter, it's entirely up to you. I find that drawing a seam along the pant leg can help convey both the structure of the clothing and the form of the leg beneath it.

6 Add the Final Details

As always, I save the fine details for last. The design work you see here on the forearm and on the boot is my own creation; you should feel free to come up with your own designs. Note that the wrinkles in the pants are largely horizontal in orientation, suggesting tight-fitting clothing.

7 Ink the Drawing

Take your pen and ink all the lines. Once the ink has dried, you can erase all the pencil lines. Nicely done! You've drawn a fellow with his feet firmly planted on the ground and begun to master the fine art of the "just standing there" pose.

Stiff Poses vs. Natural Poses: Male

It's hard enough to make a female pose look relaxed, but with male poses, the general lack of curves can make the problem even more difficult to avoid. All is not lost, though. Check out these side-by-side comparisons to see how stiff poses can be transformed into ones that look more natural.

 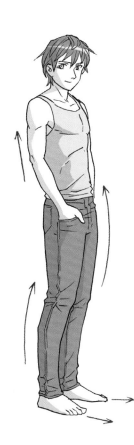 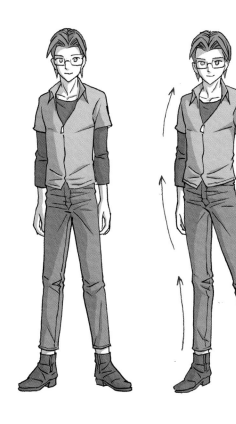

Too Straight

Here we encounter that same strapped-to-a-pole look we saw earlier. Yes, he's got a little bend to his elbow, but his spine and legs are perfectly vertical. He looks like you could give him a little nudge and he'd fall over like a tin soldier.

Subtle Angles

It's amazing what a little bend here and there can do. Now he's standing the way people do in real life: Gravity causes us to lean a little forward in the legs and a little backward with the shoulders to achieve balance. Note also how the feet point in slightly different directions, making them appear more firmly planted on the ground.

Too Straight

Now this fellow looks more relaxed than the other guy did, but there's still a whiff of the toy soldier to him. His weight is distributed evenly to both feet, giving us the feeling of a performer on a stage. What happens if he shifts more of his weight to one foot than the other?

Subtle Angles

You guessed it: He looks more relaxed and natural. Next time you need to draw a standing pose, try this method of shifting the pelvis—and thereby the perceived weight—a little bit to one side. It will help bring a feeling of relaxation to the drawing for male and female characters alike.

Running Poses

If we want to avoid an appearance of stiffness in characters who are just standing there, then we are all the more eager to avoid it when drawing characters in motion. In this lesson you'll draw a sci-fi character who is leaping into action, ready to take on the baddies. By completing the steps you can learn the process of drawing your own characters in other such high-energy poses.

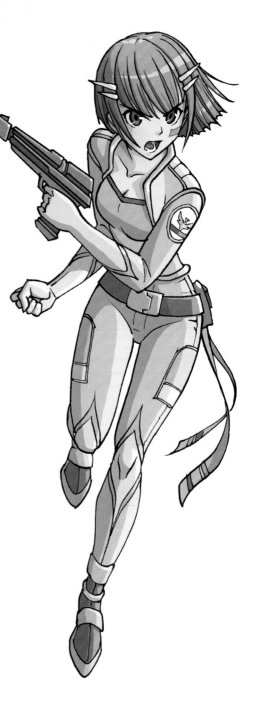

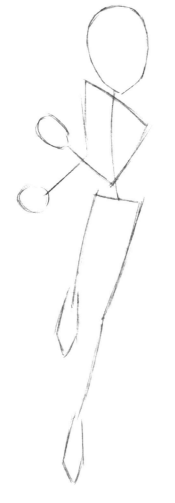

1 Draw a Stick Figure

Starting with a stick figure, get down the basic lines of the pose. As always, the proportions are important, including the length of the legs compared to the arms, the width of the head compared to the shoulders and so on. The angles are just as important. She's turning her body, causing the shoulder line to point in a different direction from the line of her pelvis.

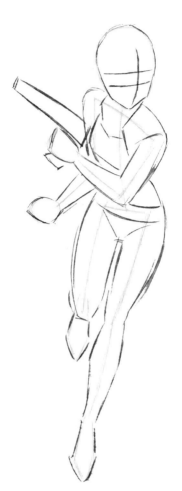

2 Flesh Out the Figure and Draw the Face Guidelines

There's a lot to do here, but remember it's all still rough—no need for perfection at this stage. As you flesh out the arms and legs, pay attention to their widths at all the various points, top to bottom. The guidelines for the eyes are widely spaced, setting us up for a classic big-eyed manga face.

3 Start the Features, Hair and Clothes

Now begin to refine things a bit in the upper half of the drawing. At this stage you're sketching in the basics of anatomical features like the face and the hands. But you can also start making choices about the clothing and hair and weapon. I decided to coordinate the facial expression with the pose, giving her a look of courage and determination.

4 Continue Sketching the Clothing and Feet

In drawing the contour of the legs, pay close attention to the shape of the feet: The length and angle of each line is quite specific. But a lot of this step is about clothing details. I chose to add a couple straps of cloth to her belt, both to make the design more distinctive and to bring more motion to the pose.

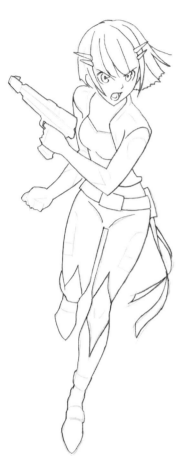

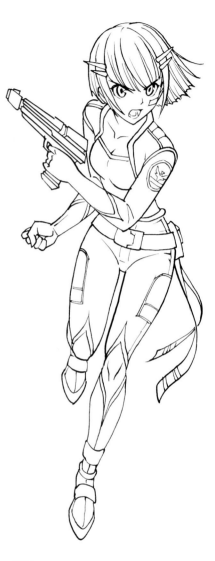

5 Finalize the Contour Lines and Add Face Details

Having worked out the most important structural lines, you can now move on to finalizing the facial features and the contours of the pose. I decided to put unusual futuristic clips in her hair, but you may come up with a different method of adding visual interest to her look.

6 Add the Final Details

For me, a sci-fi design is all about the details such as the patch on her arm, the clasps on her feet and even the way her belt buckle locks together. All of these things play a role in making her design unique.

7 Ink the Drawing

Switch from pencil to pen, and ink all the lines. Give some time for the ink to dry, then erase all the pencil lines. When it comes to action poses, the more of them you draw, the better you'll get. My advice is to take a little extra time with the stick figure at the beginning. Don't move forward until that initial pose looks good to you.

Intensifying the Action

Any action pose you draw can be made more or less intense depending on the artistic choices you make when sketching the pose. Let's have a look at three different variations on the pose you just learned.

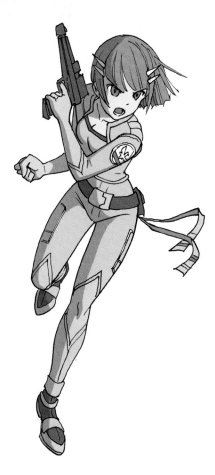

Low Intensity

In this version I've dialed back the energy of the pose considerably. By removing any diagonal tilt to her spine, I've reduced the sense of motion. Both of her feet are close to the ground, and the arm holding the laser gun is bent at the elbow though only to a very small degree.

Increasing Intensity

Now we've taken the previous lesson's pose and begun to increase the sense of urgency. The foot on the left is high off the ground. The elbows are both at 90-degree angles. The whole body is leaning diagonally, helping us to imagine her moving left to right.

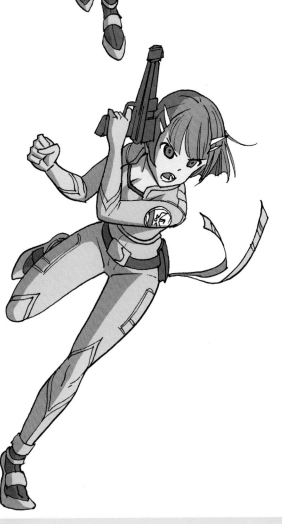

High Intensity

Here we've taken all of this even further, pulling out the stops to show her sprinting into battle. Any action pose you learn can be altered in similar ways to either increase or decrease the amount of perceived motion. Next time you find a pose you like, why not give it a try?

Foreshortened Poses

Manga is by definition a flat, two-dimensional art form. Perhaps that is why manga artists are so frequently tempted to employ the magic of forced perspective: enlarging the size of a hand, reducing the size of a leg and so forth in order to make a character appear three-dimensional. The effect can be dazzling, but for the beginning artist it can be hard to understand the process of making such drawings.

In this lesson you'll draw a character who appears to leap right up off the page, and in so doing begin to unlock the secrets of forced perspective.

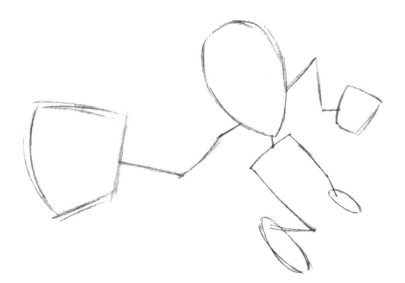

1 Draw a Stick Figure

Let's begin with a basic stick figure. As you picture a figure leaning dramatically forward toward the viewer, you can imagine parts of the body getting blocked by other parts. In this lesson's pose, the neck and torso are largely obscured. The part closest to the viewer—the palm of the hand—needs to be drawn larger, while the one farthest from the viewer—the foot on the lower right—needs to be drawn smaller.

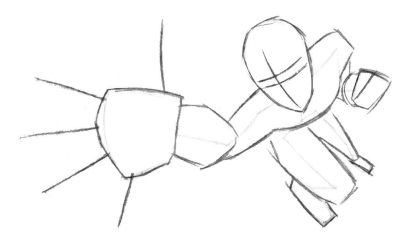

2 Flesh Out the Figure and Draw the Face Guidelines

Now we can begin fleshing things out a bit. Start with the closest hand, adding simple lines for each finger. As you continue to the forearm, designate that part as a second zone: smaller than the hand, but only by a little. The shoulders and chest become a third zone and so on, until you reach the far leg; the final zone, exaggeratedly small, so as to appear super far away.

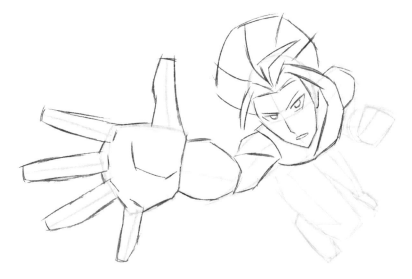

3 Refine the Structure and Start the Features and Hair

Sticking with fairly rough lines, start refining the structure you've put in place. I find that squaring off the fingers helps me deal with the complexities of the hand in a more manageable way. As always, you should regard this hairstyle as a mere suggestion. If you can make it your own, by all means do so.

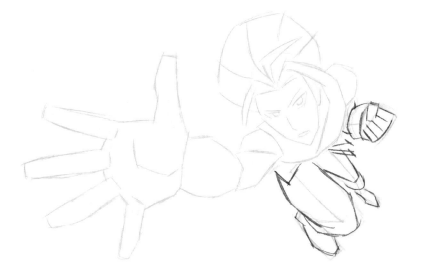

4 Refine the Structure of the Lower Body

Forced perspective often results in your being able to get away with skipping things altogether. The lower part of the leg on the left, for example, is almost entirely obscured by the thigh. As a result you draw the knee and the foot and pretty much nothing in between.

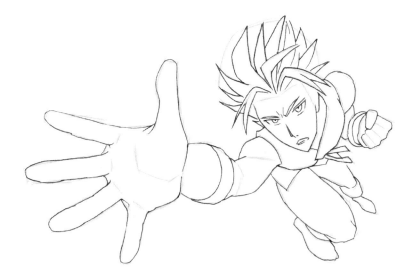

5 Finalize the Contour Lines and Add Face Details and Clothing

All the rough guidelines from the earlier steps allow you to begin finalizing the contours and the facial features. Note how the squared-off fingers from step 3 can now be refined into shapes that are more anatomically accurate. Now is also a good time to get the basics of the clothing in place.

6 Add the Final Details

With forced perspective it's especially important to save the details for last, since the job of getting the proper structure in place is such a challenging one. The lines of the hand, the details of the hair, the wrinkles on the clothes—all these things really can't be rendered accurately until you've determined the fundamental aspects of the pose.

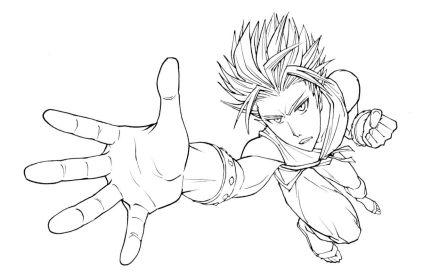

7 Ink the Drawing

Switch from pencil to pen, and ink all the lines. Allow plenty of time for the ink to dry, then erase all the pencil lines. I wish I could say this single lesson is all you need to master forced perspective, but it's just not true. Think of it as a starting point, the beginning of a journey that can lead you to mastery in the years ahead.

Different Levels of Forced Perspective

Forced perspective is a drawing trick that can be used in both subtle and not so subtle ways. Have a look at these three different poses and compare the degree to which forced perspective is deployed.

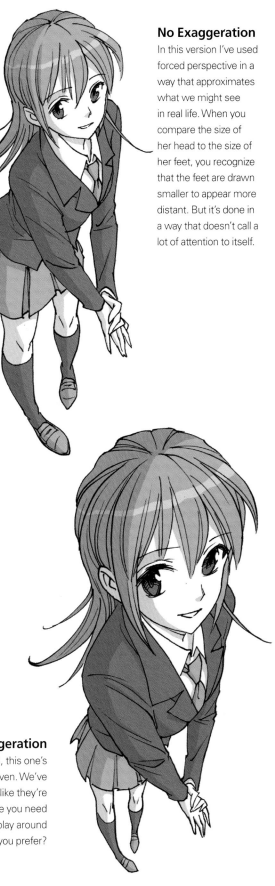

No Exaggeration

In this version I've used forced perspective in a way that approximates what we might see in real life. When you compare the size of her head to the size of her feet, you recognize that the feet are drawn smaller to appear more distant. But it's done in a way that doesn't call a lot of attention to itself.

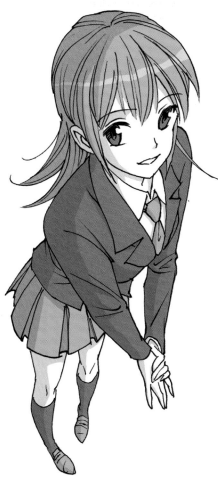

Some Exaggeration

Now we've moved to a more exaggerated form of perspective, one that is decidedly cartoony. Her feet are tiny and seem to stretch off into the distance in a stylized way. No one viewing this version will fail to notice the use of forced perspective.

Extreme Exaggeration

If forced perspective were controlled by a dial, this one's dial would be turned all the way up to eleven. We've made her feet and legs so small they look like they're being pulled into another dimension. Next time you need to do a forced perspective drawing, why not play around with variations like these to see which form you prefer?

Boy Carrying a Girl

Poses involving two different characters always present challenges, but if one of the characters is actually carrying the other … well, let's just say it's easier to get it wrong than to get it right! Never fear: In this lesson we'll learn how to draw such a pose in a way that is playful as well as romantic.

1 Draw Two Stick Figures

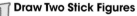

Let's begin, as always, with a couple of basic stick figures. I suggest starting with the male character to get the length of his arms right before adding in the female figure. I chose to put her legs at slightly different angles below the knees to make the pose more lively.

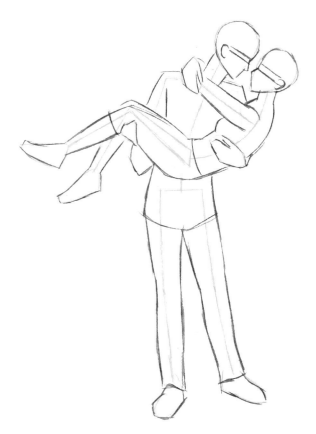

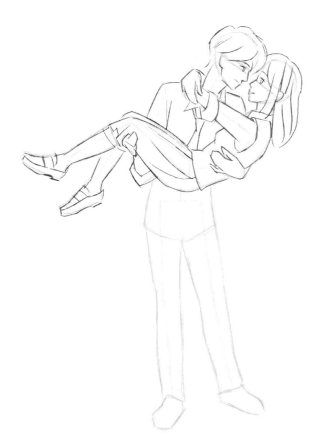

2 Flesh Out the Figures and Draw the Face Guidelines

With the foundation in place, you can begin building out to the basic anatomy of both figures. You may want to make his neck thicker than hers, as I have done here, to accentuate his masculinity. Hold off on all the details. Your concern at this stage is the "big picture" stuff.

3 Refine the Upper Half of the Drawing and Start the Features and Hair

Start refining the upper half of the drawing. The basics of the hair and clothing can all be sketched in with just a few lines. Feel free to make it your own, changing the hair or the clothing or both.

4 Continue Sketching the Clothing and Feet

Continue this process until you've sketched the lower half of the drawing as well. See how I've put in a few wrinkles at the bottom of each pant leg? This is one of the places where clothing folds often occur, and I almost always include them in some form.

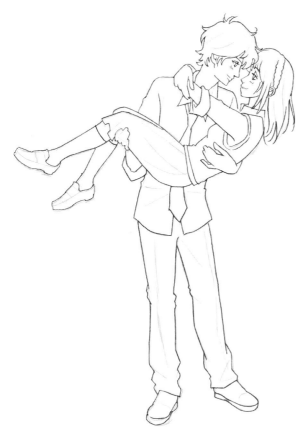

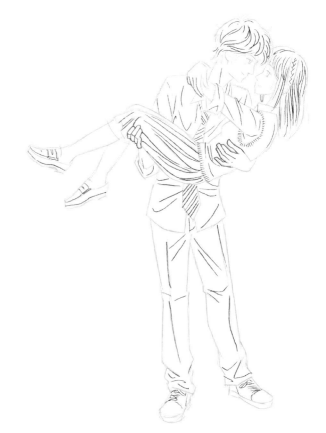

5 Finalize the Contour Lines and Add Face Details

Now it's time to refine the contours of both figures as well as the facial features. The goal here is to have them gazing into each other's eyes, so you may need to take extra care to get the irises of each eye to line up.

6 Add the Final Details

As always, the final stage is to get into the details of the hair and the clothing folds. If you've chosen to dress your female character in a pleated skirt, you can use the lines of the pleats to convey the form of her legs beneath.

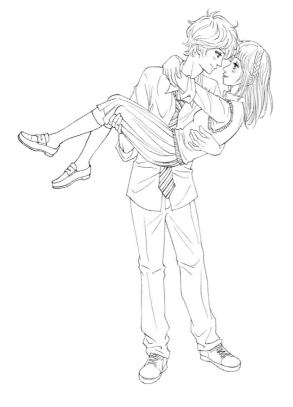

7 Ink the Drawing

Switch from pencil to pen, and ink all the lines. Allow plenty of time for the ink to dry, then erase all the pencil lines. No question: This is one of the more challenging lessons in the book. But if you're patient and see it through to the end, you'll be rewarded with a charming and memorable pose.

Body Language

Characters' emotions are conveyed primarily by way of their facial expressions, but body language can be an important factor in how that emotion comes across. Have a look at these three examples to see the power a pose can have when it comes to projecting your character's emotions.

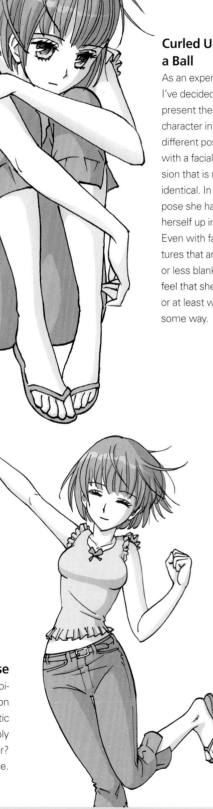

Curled Up in a Ball

As an experiment I've decided to present the same character in two different poses but with a facial expression that is nearly identical. In this first pose she has curled herself up into a ball. Even with facial features that are more or less blank, we feel that she is sad or at least wistful in some way.

Arms Crossed

Now we see the same character with her arms crossed but with the very same blank expression. The sense of sadness is not so clear now. And while we don't necessarily feel she is angry, she is certainly not coming across with the fragility we saw when she was curled up in a ball. Body language is clearly an important tool for making sure readers know how a character feels.

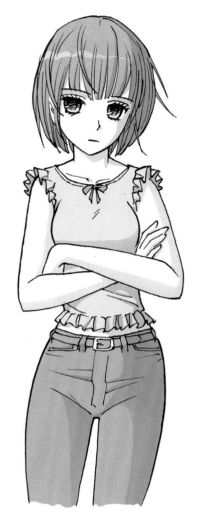

Elation in the Pose

With this drawing I've tried the challenge of conveying happiness mostly by way of the body language. Yes, the emotion is there on her face, but only just barely. It is the energetic angles of her arms and legs that make us feel she's incredibly happy. Want to make your character's emotional state clear? Don't forget to show it in both the body and the face.

Sword Clash

If I had to name the weapon of choice for manga artists, I'd say there's no contest; its the sword. Something about this ancient and noble weapon fires the imagination, transporting readers to magical realms and faraway places.

In this lesson we'll learn how to draw a classic clash of sabers, which of course requires drawing not just one pose, but two. Even if swords aren't your thing, it's a good way of learning to draw action poses and how to illustrate a conflict at its very peak.

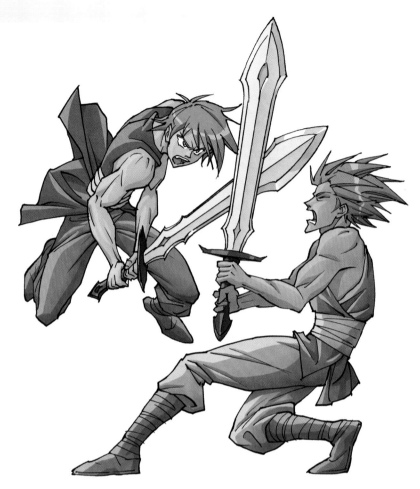

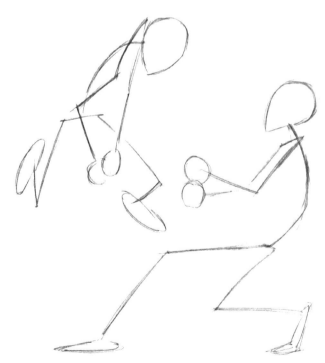

1 Draw Two Stick Figures

Let's begin with the basic stick figures. I've chosen to place the figure on the left in a heightened position of power, leaping into the air as he strikes. Note how the angle of the shoulders is drastically different from that of the pelvis; this twisting pose is a common choice for action as it suggests fluidity of motion. Sharply bent knees and elbows add to the sense of drama and impact.

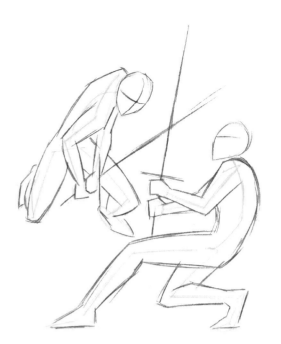

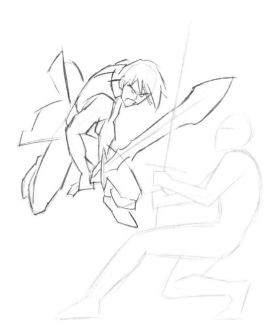

2 Flesh Out the Figures and Draw the Face Guidelines

As you begin fleshing things out, focus on the basics: the width of the thigh compared to the upper arm, the angle of the head, the curve of the back as it joins the shoulder. I've sketched in the swords here but only just barely. We just want the big picture at this stage.

3 Start the Upper Figure's Features, Hair and Clothes

Begin tightening things up just a little. Confining your attention to the upper figure, sketch in the facial features and the hair as well as a few indications of clothing. I've chosen a highly stylized fantasy sword, but you may prefer something more streamlined. Note how the clothing can add to the sense of motion.

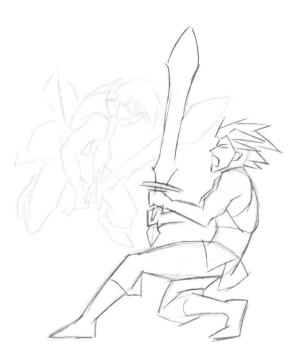

4 Start the Lower Figure's Features, Hair and Clothes

Onward to the second figure. Remember that hair and clothing are entirely up to the artist—no need to replicate what I've opted for here. It's a good time to get a sense of the musculature of the upper arm but just in a rough way for now.

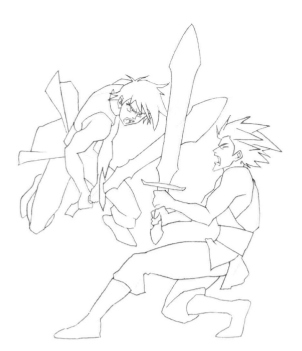

5 Finalize the Contour Lines and Add Face and Hair Details

Once you've worked out the basic forms, begin refining the contours. I've opted for a somewhat stylized approach, drawing their arm muscles with super-sharp angles to accentuate the physical demands of the battle. Now's the time to go for the details of the facial features and to finalize the hairstyles.

6 Add the Final Details

As always, the details come last. As you can see, I've gone for quite a lot of detail throughout both poses, but you may opt for a more minimal approach. Note how the cloth wrinkles aren't just random lines; they are responding to the movement of the bodies beneath, showing us how the cloth is being pulled in a particular direction.

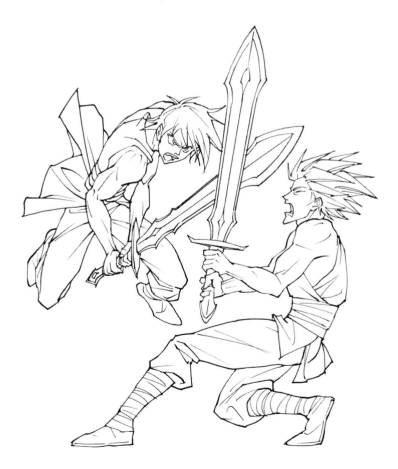

7 Ink the Drawing

Time to ink all the lines. Allow plenty of time for the ink to dry, then erase all the pencil lines. The goal of every artist is to be able to draw poses like this entirely from memory. It doesn't happen magically overnight though. You get there slowly over a period of years by copying various poses at first, then gradually learning to create your own.

Sword Poses

Any pose that involves a sword has a good chance of being a visually interesting one. The sword itself brings a bold element to the design, dividing the image in a memorable way. Have a look at these three illustrations to get some ideas for your own sword poses.

Japanese Style

This character has some of the hallmarks of an ancient Japanese swordsman but with a healthy dose of fantasy mixed in. Note the decisiveness of the stance: He is shifting his weight to one side, giving the pose a sense of movement.

Standing His Ground

Not every sword pose needs to be pulled from the thick of battle. Indeed, your manga story may call for a page or two of dialogue prior to the fight. At such times the sword remains part of the pose, a silent promise of action yet to come.

Ready to Strike

Here we see a character in the midst of battle, sword raised and ready to crash down upon her foe. The pose is made dynamic by its diagonal movement; we can almost see the energy moving toward the upper right.

Action Poses

If learning to draw action poses is your number one priority, it will require practice and patience. But here are four basic tips that can help you along the way.

There's Action in the Angles

In comics there is a tradition of big heroic action poses where the main goal is to make a lasting impression on the reader. More often than not these poses include sharp angles of the arms, legs and spine—everything tensed and ready for battle. When designing your own action poses consider pushing things to the limit like this even if you have to bend the rules of anatomical accuracy to get there.

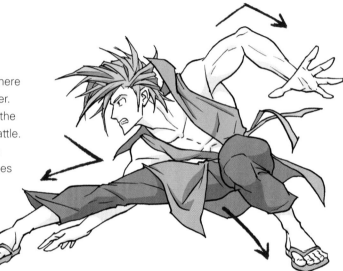

Consider the Use of Forced Perspective

Not every action pose calls for forced perspective, but it can be a very useful tool. Compare these two subtly different drawings.

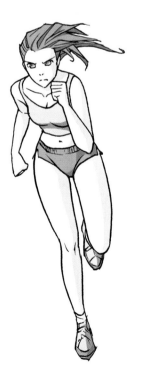

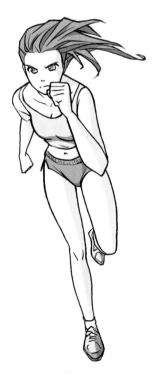

No Forced Perspective (Left)

This woman looks like she's moving pretty fast, but could forced perspective help her pick up the pace?

Some Forced Perspective (Right)

I have enlarged the upper half of her body: the torso, the shoulders and especially the head and forearm. These little exaggerations make her pop forward out of the page and increase our sense of her speed.

Start With a Thumbnail Sketch

Before launching into an ambitious drawing, work out the bugs with a few super-simple thumbnail sketches.

An early thumbnail (1) establishes what I'm going for: a guy leaping forward. Next I work my way toward a usable final pencil (2). By keeping things loose, I can change my mind with a minimum of heartache at this stage.

Having worked out the basics in thumbnail form, I can move on to creating the final illustration (3). Behind any great artwork you will find thumbnails of this sort: They are the foundation upon which everything else is built.

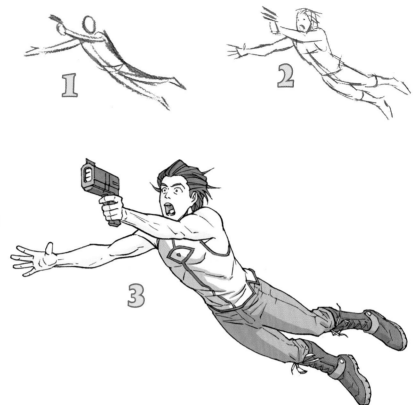

Clothes and Hair Can Add to the Effect

When we think of action poses we naturally think primarily of the body itself and what it's doing or is about to do. But clothing and hair play an important supporting role. Compare these two versions of the same drawing.

Tame Clothing and Hair

Here we see what happens when the clothing and hair are drawn in a very tame way as if they are unable to react to the motion of the pose. It's almost as if she's frozen in space and time.

Active Hair and Clothing

Now the hair and clothing are getting in on the action. Though her arms and legs are in the same positions, there is a much greater sense of movement in this version.

Shojo Poses

Action poses are important, but sometimes the pose you're looking for is something a little more quiet and serene. Shojo manga stories in particular often require an artist to deliver images of understated beauty with characters who look relaxed and at peace rather than tensed for conflict. In this lesson we'll draw a character in one such pose, an illustration that requires a light touch and careful attention to matters of human anatomy.

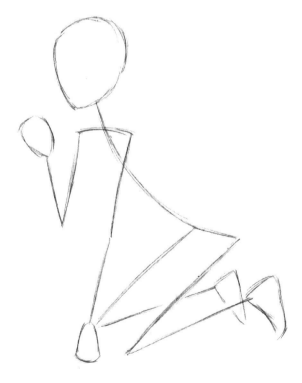

1 Draw a Stick Figure

Even at the stick figure stage, you can see a bit of manga-style exaggeration in the approach to proportions. The head seems quite large compared to the body. Don't be fooled, though. The anatomy will be fairly realistic by the time we're done.

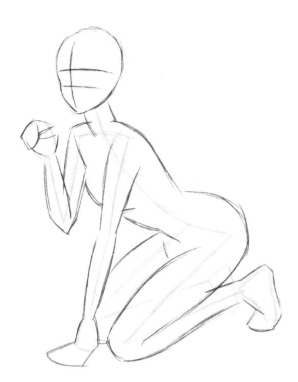

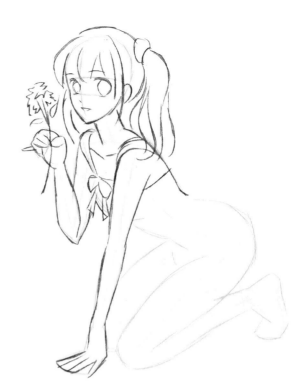

2 Flesh Out the Figure and Draw the Face Guidelines

Lots to do here, but remember there's no need for perfection; all you need at this stage are loose, sketchy guidelines. Pay attention to the width of the and the narrowness of the wrists and ankles. One key point is the area where the arm that's closer to us joins the shoulder. Get those lines in the right place now and you'll save yourself a lot of grief later on. When placing the guidelines for the eyes, space them widely so as to make way for large eyes, in the classic shojo tradition.

3 Start the Features, Hair and Clothes

Begin working your way toward the most important lines of the upper body. Note the balance of the facial features: The large eyes are paired with a tiny nose and mouth. The hair and clothing can be altered to suit your tastes, but make sure they look natural. The shoulder straps here, for example, curve across the shoulders in a way that fits the form of the body beneath them.

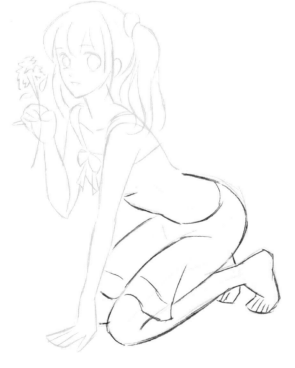

4 Continue Sketching the Clothing and Legs

Continue to sketch the lines of the legs and feet, keeping your focus on the basic forms rather than the details. Take your time with the feet. See how the lines of the toes fan out a bit from left to right? Accuracy in that area can make a big difference in the final drawing. The line at the waist is related to the clothing, but it also helps convey the structure of the body.

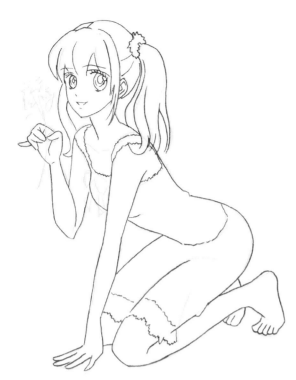

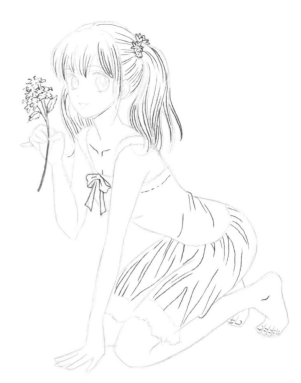

5 Finalize the Contour Lines and Add Face and Hair Details
Time to finalize the contour lines and the facial features. Go slowly when drawing the fingers: Whether it's the right hand or the left, you're dealing with a delicate arrangement of lines, and great care is needed to get the angles and proportions just right. This is also a good time to finalize the basic contours of the hairstyle, determining in what direction the various strands will flow. When adding the details of the eyes, feel free to experiment. Longer eyelashes? Smaller pupils? So many possibilities!

6 Add the Final Details
If you took your time with the earlier steps, these final details should be easier than they look. Drawing clothing wrinkles is always challenging, but sometimes just a few lines is all you need. In the area of her waist, for example, it all comes down a few little lines, fanning out from around her lower back. You could apply the same principle to the skirt and simplify things a great deal.

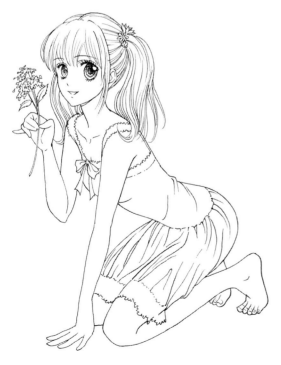

7 Ink the Drawing
Grab your pen and ink all the lines. Note that the inking style here is very light and delicate rather than thick-lined and angular. Allow plenty of time for the ink to dry, then erase all the pencil lines.

Every pose you learn is a stepping-stone toward other poses. If you'd like advice on taking one pose and altering it to create new ones, well, hey, that's what I'm here for! Have a look at the very next page.

Variations on a Pose

Every time you learn to draw a particular pose, you have potentially learned how to draw hundreds of poses. All you need to do is alter some small part of it, and it becomes something new. The more you practice, the better you'll get at it. Have a look at the three poses on this page, all of them derived from the one you just learned in the step-by-step lesson.

Peace Sign

This pose is really quite similar to the step-by-step version, but we have begun to "move the camera," imagining what she would look like if we were standing just a little to the left. Try doing the same thing with any of the poses you've learned in this book. It's a great way to gradually improve your sense of what the human body looks like in three dimensions.

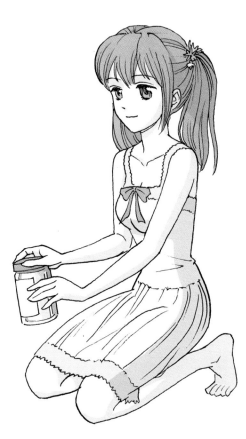

Opening a Jar

Now we've changed things a bit more significantly, moving both her arms and her hands into different positions, and having her sit up straight rather than lean forward. This is another way of honing your pose-drawing skills. Start with the part you've already learned—in this case, her legs—and then experiment with changing other parts of the drawing to devise a new pose.

Tying Up Her Hair

Little by little you can take on greater challenges. Here I've had to think about what she would look like with her arms raised, back arched and head tilted forward. Rather than try to draw poses completely from scratch, try starting with a pose you've already learned. It may give you the head start you need toward getting the result you're looking for.

Imaginary Animals

Certain manga stories are so imaginative they can't be satisfied with a typical dog or cat coming along. They call for newly invented creatures, ones that possess a number of animal-like features—paws, wings and the like—but who look nothing like animals we could find in the real world. In this lesson I'll show you how to draw several imaginary creatures that could fit into this popular manga tradition.

1 Draw the Head and Torso Guidelines

Let's start by drawing guidelines for just the heads and torsos. I've chosen to arrange the three creatures into a single illustration. If you'd like to use this approach, take care to replicate the spaces between each animal.

2 Refine the Structure of the Top Animal

Now let's turn our attention to the creature on the upper right. Note that he is turned in a three-quarter view, causing the facial features to shift to the right. I encourage you to customize each animal and make it your own. Want the ears to be shorter? Or for there to be no ears at all? Go for it!

3 Refine the Structure of the Middle Animal

For the second animal I've decided to go for a birdlike look. This one is facing the opposite direction from the last one, so the beak is way over on the left, touching the contour of the head. Note the up-and-down pattern of the feet. This is a simple way of conveying energetic movement.

4 Refine the Structure of the Bottom Animal

Finally we come to our four-legged friend at the bottom, a doglike creature. See how the tip of the tail curls over itself? This is a nice way of livening up the drawing. The rear legs have a bend to them, whereas the front legs remain straight.

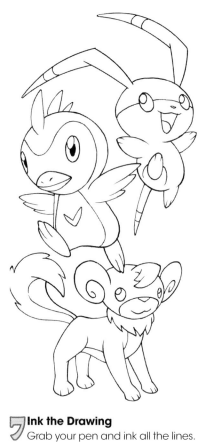

5 Finalize the Contour Lines

Now it's time to refine the contours of all three creatures. I've split the wings into a few feathers each and added some furlike zigzags to the doglike animal. Again, don't hesitate to customize any of the drawings if you are inspired to do so.

6 Add the Final Details

These creatures are deliberately simple in their designs, so there's not too much to fuss over in terms of details. Making a foot look pawlike can be as easy as just adding a couple of short lines. To make the eyes appear shiny, every eye gets its own highlight, a little circle of white in the upper part of each iris.

7 Ink the Drawing

Grab your pen and ink all the lines. The challenge here is to ink every line with a single stroke if you can. The goal is a clean cel-animation look, and that's hard to achieve if you go over each line multiple times.

Changing Your Design

Real creativity is all about making choices. There are always lots of different ways to do something, and your job is to figure out which one of them is the best way. You do that by trying out different possibilities.

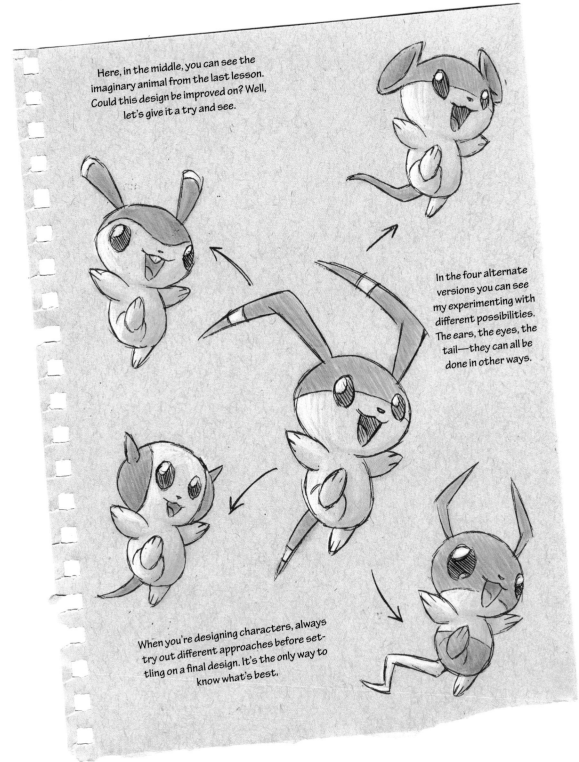

Here, in the middle, you can see the imaginary animal from the last lesson. Could this design be improved on? Well, let's give it a try and see.

In the four alternate versions you can see my experimenting with different possibilities. The ears, the eyes, the tail—they can all be done in other ways.

When you're designing characters, always try out different approaches before settling on a final design. It's the only way to know what's best.

Manga Monsters

I've tried to expand the scope of this book to cover characters that aren't just average everyday human beings. In earlier lessons we looked at alien characters and animal characters. But what about those times when you have something a little more sinister in mind? Sometimes you need a character that is more monster than man, yet you still want it to fit in within a manga-style world. In this lesson we'll learn to draw just such a creature.

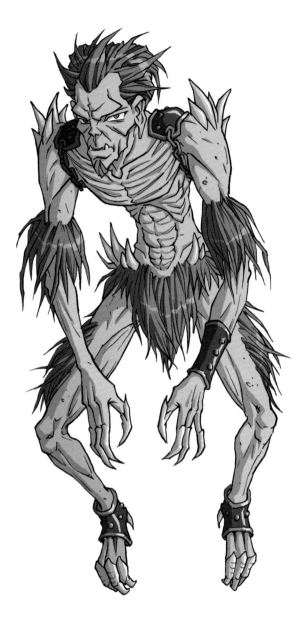

1 Draw a Stick Figure

Even when drawing a monster, I still begin with a stick-figure framework of some kind just to give myself something to build off of. Happily, we are within a realm of complete fantasy here, so you can feel free to come up with any proportions you like. I've given this guy arms that are nearly the same length as his legs, but you may make choices that are much more daring.

2 Flesh Out the Figure and Draw the Face Guidelines

Keeping things loose, begin to sketch out the basic contours of your creature. I'm not concerning myself with each individual finger. I'm just dashing in a few lines to get a sense of the directions they'll be heading in. Note how broad I've made the shoulders; it's a common design choice for conveying brute strength.

3 Start the Features, Hair and Upper Body

Designing a monster character allows you great freedom, and if you're not careful, things can quickly devolve into a jumble of weird, clashing attributes. I find it's best to settle on just a few. I decided he'd be muscular with patches of fur and outcroppings of horns. Though I'm not going for fine details at this stage, I am devoting attention to the facial features and the hands.

4 Continue Sketching the Clothing and Lower Body

Characters who bear little resemblance to humans can still benefit from being partially grounded in human anatomy. Notice how I took a moment to draw lines around the edges of the knee-caps. Recognizably realistic anatomical features like this can help balance out the more fanciful features of the design, making the whole character seem more believable.

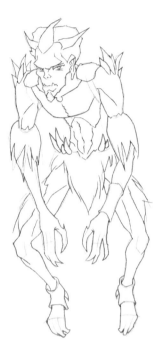

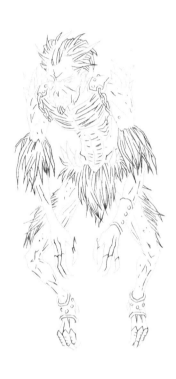

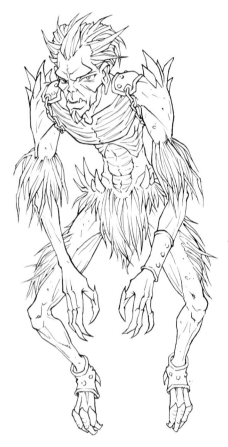

5 Finalize the Contour Lines and Add Face and Hair Details

Here's where you can begin finalizing the facial features and the contours of the body. For my creature I chose to put extra emphasis on the structure of his forehead, giving him a sort of permanent scowl. Note that there's no particular pattern to the horns on his shoulders. It's an organic approach, determined entirely by what looks good to me as a designer.

6 Add the Final Details

As always, the level of detail you go for is up to you. One nice thing about drawing fur on a monster character is you are liberated from any need to make it smooth and delicate looking. You can just jump in there and make it all ragged and unkempt. Similarly, the process of delineating muscles is quite freeing: These are monster muscles and they can have any look you want them to have in the end.

7 Ink the Drawing

Switch from pencil to pen, and ink all the lines. Leave time for the ink to dry, then erase all the pencil lines. Add color if you like, or just leave it as is. My approach to inking an illustration like this is to use angular lines, creating lots of sharp edges. In this way, the inking contributes to our sense of the monster's character.

Creature Features

For me the key to designing a believable monster is to have as much of it based on real-world anatomy as possible, whether it be human anatomy or that of animals. Here you can see three examples of monster detailing, all of which are inspired by animals we can find in real life.

Reptilian Claw

This may look like it came to us by way of *Jurassic Park*, but its origins are much more humble: It is largely inspired by a chicken foot. Yes, you can give your monster a reptilian claw that comes entirely from your own imagination, but if you base it on something from the real world, a certain authenticity will shine through.

Fur-Covered Hand

This monstrous hand is based on the hand of a gorilla, especially in terms of the fingers and knuckles. The claws belong more to the realm of fantasy, but note how I have curved them so they fit naturally with the fingers they are attached to.

Horns

Drawing horns has always been, for me, one of those things that's easy in theory but difficult in practice. Which way do they curve? How do I render their surface to give them a look of solidity? By studying photo reference of a ram's horns, I was able to create the monster horns you see here. They look a whole lot better—trust me—than they would if I'd tried to just invent them out of thin air.

Strategies for Drawing Hands

No matter how talented you are as an artist, I'll bet you've struggled with drawing hands at one time or another. They are structurally so complex that it's devilishly difficult to visualize what they look like from every possible angle. Here are a few tips and a couple of step-by-step lessons that should help you make progress in the struggle to draw hands well.

The Length of the Fingers

You can take a huge leap forward by memorizing how long the fingers are in relation to one another. The middle finger is the longest. The index finger and the ring finger are tied for second place. And the pinky is quite noticeably shorter, a distant third. The artist who knows these measurements has a huge advantage when it comes to drawing hands.

The Ball of the Fist

When drawing a fist, try following this little three-step procedure.

1 Draw and Divide a Ball
Begin by drawing the fist as an oval-ish ball. Note that the wrist doesn't connect to the fist in the dead center: It is shifted closer to the pinky side and away from the thumb side. Divide the fist with an L-shaped line to separate the finger area from the palm area.

2 Add a Thumb and Divide the Fingers
Add a long oval for the thumb, pointing diagonally into the finger area. Then divide the finger area into four boxy subsections, each fanning out across a curved line for the knuckles. A line across the wrist conveys the wrinkles that form there.

3 Refine the Shapes
Now that have the basic structure in place, you can refine things. Break up the contour in the area of the fingers so we can see the individual knuckles. A single line in the middle of the palm can help convey the structure there. The thumbnail is a nice detail, but it's not essential, especially when the fist is seen from a distance.

Start With the Palm

When I'm drawing an open hand I use a method that's different from the balled-fist approach. Follow this four-step lesson for help drawing almost any hand where the fingers aren't closed tight.

1 Draw the Palm Shape
The fingers are the hard part, so it can be helpful to begin with just the palm. I think of it as a square shape pivoting off the wrist as if it were on a hinge.

2 Add the Thumb and Finger Structures
Once the palm is in place, you can begin building the basic structures of the thumb and fingers. At this stage I leave the fingers mittenlike, a single shape, lightly divided down the middle.

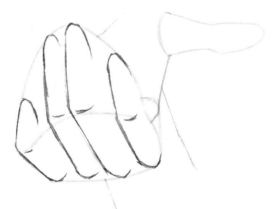

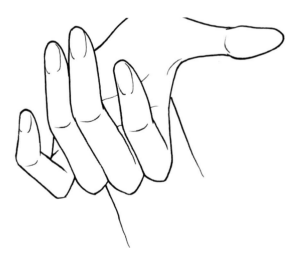

3 Define the Individual Fingers
Only now do I attempt the individual fingers, taking my time and working toward them little by little. Artists often choose to have two of the fingers joined, as I have done here with the two in the middle. It creates an elegant look.

4 Add the Final Details
And so I am able to finalize things, saving minor details, like fingernails, for last. I find that starting with the palm—rather than the fingers—is a good way of understanding the structure of the hand so as to draw it more accurately.

Mecha Robots

The concept of humanoid robots goes back many centuries, and Hollywood has presented visions of them from its earliest days. But something unique happened when Japanese artists got hold of the idea. They came up with a robot design that was entirely unlike what we'd seen in the West, and you need only look at the success of the Transformers franchise to see how popular and appealing their approach has become. In this lesson, we'll learn some of the tricks for drawing Japanese-style robots and in so doing discover what makes their designs unique.

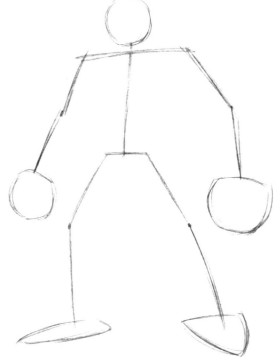

1 Draw a Stick Figure

As you may have guessed, I like to begin with a stick figure to create a basic structure on which to build. As with the Manga Monsters demo, you can feel free to alter your design drastically from what you see here. It's your robot, and it should look the way you want it to. Consider replicating this pose, though, to get the confident-looking stance you see here.

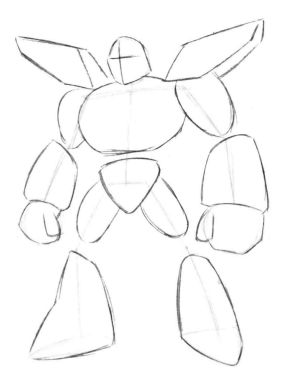

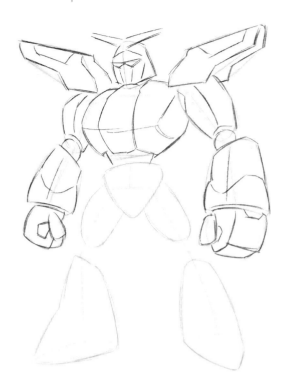

2 Draw the Big Forms and the Face Guidelines

At this stage you can begin sketching the most important big forms of your robot. I've given him a small head and placed large ornamental structures on his shoulders, two common features of Japanese-style robot designs. I've held off on drawing the knees, elbows and other joints as they are smaller in size and can be added in the later stages.

3 Refine the Big Forms of the Upper Body

Now you can begin refining the big flat shapes into something a bit more three-dimensional looking. I added a decorative element to the top of his helmet, another choice frequently seen in Japanese designs. Note how I've divided the forearms into two discernible sections. The goal is to take a plain shape and make it a little more visually interesting.

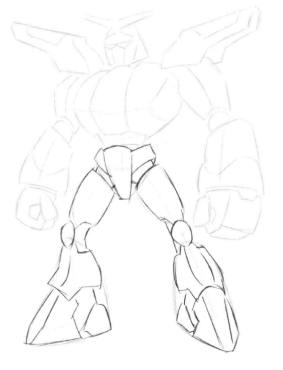

4 Refine the Big Forms of the Lower Body

Continue with this process, bringing form and structure to the legs. I've taken the robotic feet and split them into three sections, doing my best to imagine what they would look like from different angles. Though your design may be quite different, you will also need to think carefully about what your invented shapes will look like when turned in space.

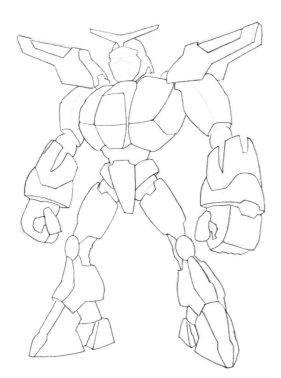

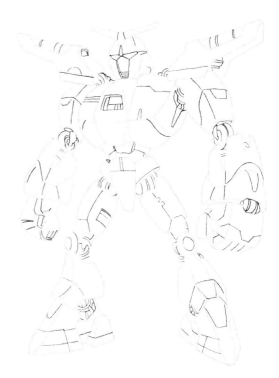

5 Finalize the Contour Lines
Once you have most of the important segments in place, you can begin finalizing the contours. Note how I took the central part of the chest and built it up into a protruding structure. This is yet another design principle inspired by Japanese robot illustrations.

6 Add the Final Details
As always, I've saved the minute details for last. Here's where you can really play around with various possibilities, experimenting until you find the formations you like best. One approach I enjoy is making various elements asymmetrical so that things on the left side are not necessarily found on the right side. It's all about keeping things from being visually predictable.

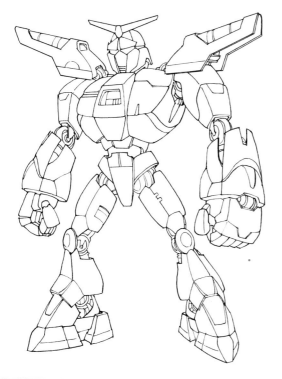

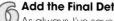

7 Ink the Drawing
Switch from pencil to pen, and ink all the lines. Allow plenty of time for the ink to dry, then erase all the pencil lines. My inking style here is very clean and smooth with very little change in the line width. It seemed to me the right approach for a futuristic mechanized character.

Different Types of Robot Design

Part of the pleasure of drawing a robotic character is the freedom you have to draw it any way you like. That said, you probably want to maintain a certain consistency within the design of each robot you come up with. Here are four different ways you could choose for the basic look of your mecha character.

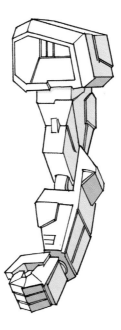

Angular

In this style nearly every line is perfectly straight, joined together at sharp angles and projecting an image of no-nonsense functionality. You can try freehanding all this if you like, but I personally would never attempt this style without a ruler in hand.

Semi-Angular

Here we see a blend of approaches. Some of the surfaces appear flat, but many of them are slightly curved. To my eye this version conveys a feeling of high-tech elegance: mechanical but with a bit of a human touch.

Super Smooth

With this method the curve takes over, and the goal is a look of pristine perfection. Note that there are far fewer subsections than in the other styles. We have the sense of a complex interior shielded behind a streamlined futuristic shell.

Rusted and Weatherbeaten

As someone who loves depicting surface detail, this is one of my favorite styles. This thing is not brand new, and you kind of wonder if it was ever brand new. No need for a ruler as the imperfection of an unsteady line actually works in your favor here.

Chibi Sword Clash

Drawing chibi characters is always fun, but it's especially interesting to take realistic-looking characters and give them the chibi treatment. For me, the more serious the original drawing, the better since you know the contrast between the real version and the chibi version will be just that much more hilarious. In this lesson you'll see how to take the earlier sword clash characters and transform them into chibis.

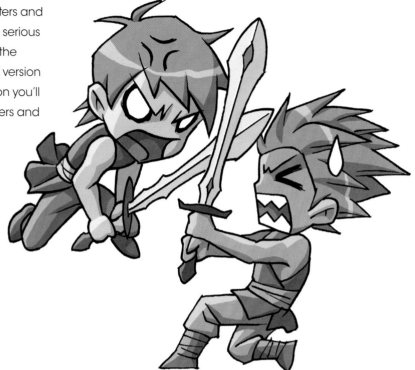

1 Draw the Head and Body Guidelines
Let's begin with a few loose guidelines. Pay special attention to the locations of the hands since you'll need the swords to line up there later on. The head shapes are different: The one on the left is a three-quarter view while the one on the right is in profile.

2 Refine the Structure of the First Character
Next begin working out the basic structure of the swordsman on the left. His mouth is open so wide it is connected to the contour line of the jaw; there is no lower lip. Note that though the hair is greatly simplified, it is still based on the hairstyle in the original drawing.

Refine the Structure of the Second Character

Now we move to the swordsman on the right. The eye has become a sideways letter V. This is a classic chibi technique for conveying the look of an eye squinted shut. There is a little zigzag at the end of the eyebrow (both here and on those of the other swordsman), which is a cartoony method of showing that his brow is furrowed.

Add the Final Details

With all the most important lines in place, you can now take care of the final details. Both of these guys have standard chibi emotional symbols displayed upon their heads. For the man on the left it is a bulging vein, a symbol of anger. For the other it is a sweat drop, a symbol of nervousness. A few more lines for the hair and clothing and you're ready to ink.

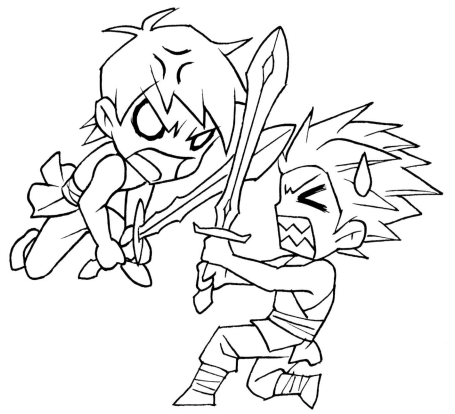

Ink the Drawing

I try to ink my chibis with as many single strokes of the pen as possible. Indeed, many chibi artists work in a very loose style, dashing in the lines with speed and spontaneity in keeping with the form's lighthearted soul. Let the ink dry, and then erase the pencil lines. Your chibi swordsmen are complete.

Chibi Girl and Chibi Kitten

Lessons about turning human characters into chibis are fairly common, but what if you want to do a similar thing for animals? Happily, many of the same guiding principles apply: Start with the real-life version and simplify, simplify, simplify. Follow this lesson to learn how to draw both a chibi schoolgirl and a chibi kitten.

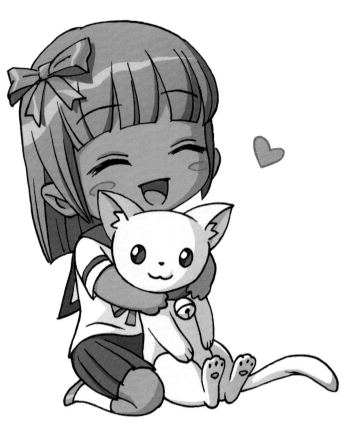

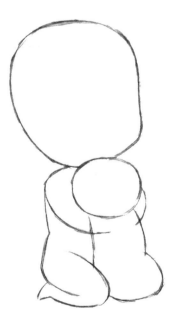

1 Draw the Basic Head and Body Guidelines
To get started we'll want some basic guidelines for both characters. And I do mean basic: All you need at this stage is the outline of her head, arms and legs, and, for the cat, nothing more than the head and body.

2 Refine the Structure of the Girl
For the next step let's focus only on the girl. Pay attention to the location of the facial features, and to the distances between the eyes and eyebrows. I've given her longish hair and a ribbon, but you should feel free to draw the hair and clothing any way you like.

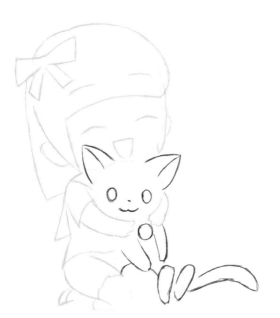

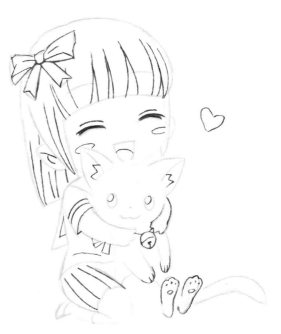

3 Refine the Structure of the Kitten
Kitty time! To make this feline youthful and cute, we need to confine the facial features to the lower half of the head. Note that the ears are drawn with slightly curved lines and that they point out diagonally rather than straight up.

4 Add the Final Details
Now we can get to the finishing touches. Though the hair is cartoony, it still follows the shape of the head to convey a rounded surface. The little ovals on her cheeks are "blushies," a cartoony way of showing that she's apple-cheeked and in good spirits. I've put spots on the kitten's paws as an added detail.

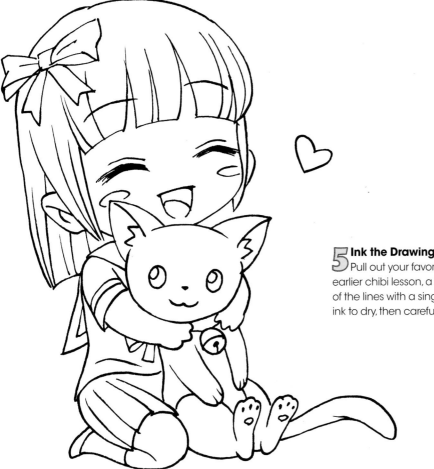

5 Ink the Drawing
Pull out your favorite pen and ink all the lines. As with our earlier chibi lesson, a light touch is advisable. Try to ink as many of the lines with a single stroke as you can. Allow time for the ink to dry, then carefully erase all the pencil work.

Finishing Touches

A manga artist's job is never done. Just when you think you've finally figured out your style and how to draw all those cool action poses, it dawns on you how much other stuff you still have to figure out. Page layouts. Adding color. And what about the front cover?

Relax. This chapter is packed with advice on all these topics and more. Whether it's drawing wings or using photo reference, the pages ahead have you covered on this last leg of the journey toward manga mastery.

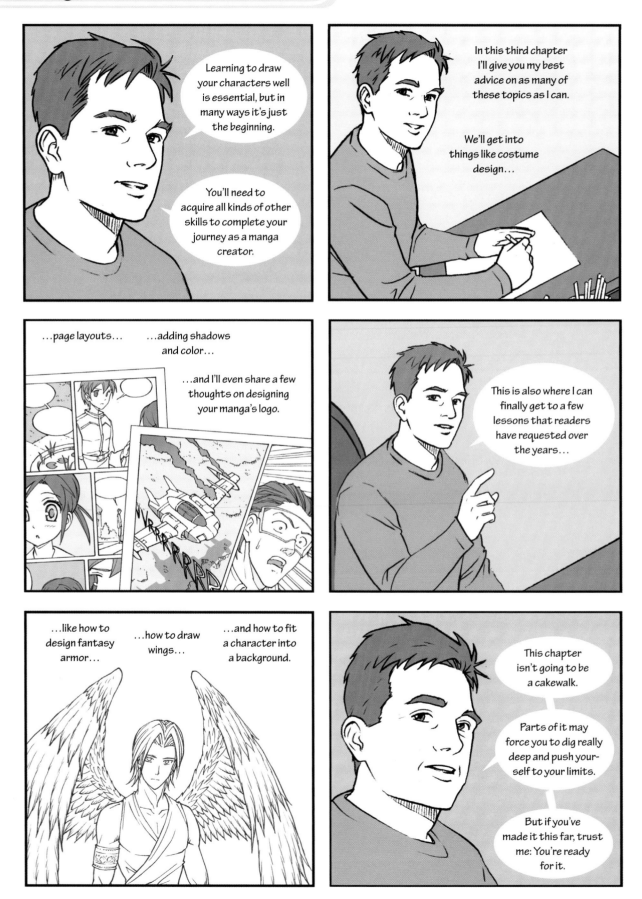

Designing Costumes

Most of the world's most popular manga characters have not only a distinctive face and hairstyle but also distinctive clothing. So you may find that among your many other jobs as a manga creator is that of being a costume designer. It can be a challenging task but is also loads of fun.

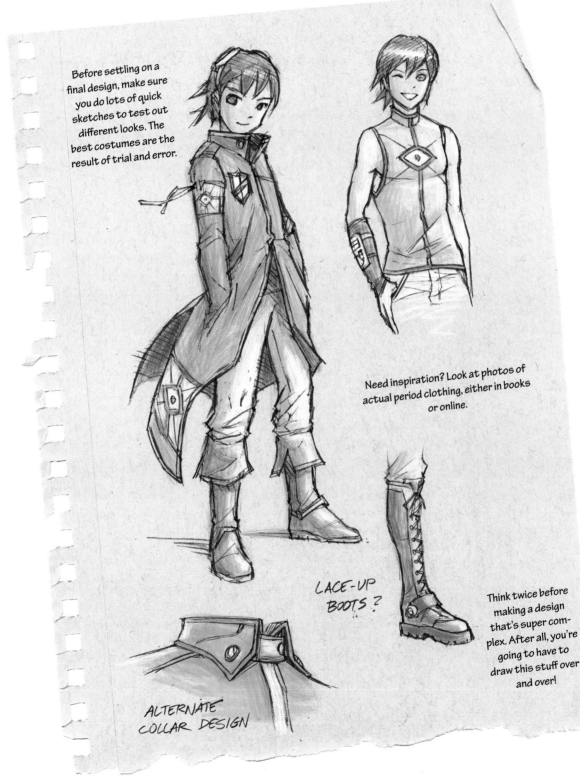

Before settling on a final design, make sure you do lots of quick sketches to test out different looks. The best costumes are the result of trial and error.

Need inspiration? Look at photos of actual period clothing, either in books or online.

LACE-UP BOOTS?

Think twice before making a design that's super complex. After all, you're going to have to draw this stuff over and over!

ALTERNATE COLLAR DESIGN

Tips on Drawing Clothing

Clothing is usually pretty high on the list of things that artists struggle with. Yes, there's the wrinkles to contend with, and I devoted a fair number of pages to that subject in the earlier books of this series. But sometimes you just need step-by-step lessons on specific types of clothing that come up in manga again and again.

Shirt Collars

1 Start With the Collar
Once you have your character's neck and shoulders in place, I advise starting with the collar itself. Collars are triangular shapes near the bottom, gradually narrowing as they curve up and around the neck.

2 Add the Button Area
Now you can move to the area where the collar gets buttoned. What you see here is a man's shirt. On a woman's shirt the whole formation is reversed, with the button on the other side.

3 Ink the Drawing and Add Details
Ink it up, adding detail to the button if you like, and perhaps a wrinkle or two at the shoulder. There you have it: an accurately drawn shirt collar.

Ribbons

1 Start With Simple Shapes
Begin with the simple arrangement of shapes you see here. It can be helpful to show the ribbon a little from above or below to reveal its structure. The two ribbon ends can be shown dangling as they are here, or hidden away as they are on a bow tie.

2 Add Some Details
All that's needed now are a few more lines to make the ribbon look more clothlike. The V-shaped lines near the knot of the bow are especially useful in this regard, helping the viewer see how everything fits together.

3 Ink the Drawing
Do your best to ink with smooth, confident lines, and voilà! An all-purpose ribbon, ready for use in your next manga illustration.

Frilly Clothing

Many manga stories call for frilly clothing, whether it be for an elegant duchess or a centuries-old vampire. All those details can seem intimidating for an artist, and without care all the various lines can quickly devolve into a mess. Follow this four-step process to learn a reliable technique for drawing frilly clothing.

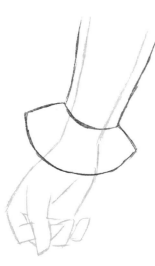

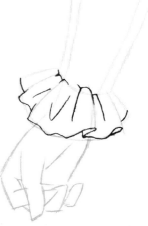

1 Determine the Frill Placement
The first step is to decide where you need the frills to be. In this example I've decided to add frills to the cuff of a shirtsleeve. Knowing that I want the frills to puff out a bit, I've extended the contour of the cuff area out a generous distance from the wrist on both sides.

2 Divide the Cuff Into Pleats
Rather than try to jump straight into the details, I limit myself to dividing the cuff area into a few pleats. Note that each line fans out a little from the wrist like a ballerina's skirt. The largest pleat is in the middle, and it is shown to be out in front of the other pleats.

3 Add the Final Details
Now that I've decided my basic underlying structure, I can begin making the bottom edge of the cuff area more wavy and irregular. Sometimes bits of the underside can be seen, helping us understand how the cloth is folding in on itself. See the J-shaped line in the middle of one of the pleats? This is a very useful tool for making cloth appear frilly.

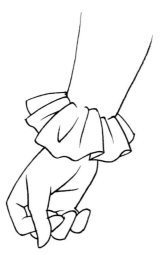

4 Ink the Drawing
When inking clothing like this, the goal is smooth, steady lines, as many as of them as possible laid down with a single stroke of the pen. Feel like you need more practice? Never fear. Other lessons in this very book will have you making use of this technique.

Adding Wings to a Character

Not every story includes a winged character, but when you've written such a story you'll definitely want a little help drawing them. The basic structure is tricky enough, but then you have all those feathers to contend with. It's tricky stuff, to be sure, but if you follow this lesson you'll gain a reliable method of drawing wings that look natural and real.

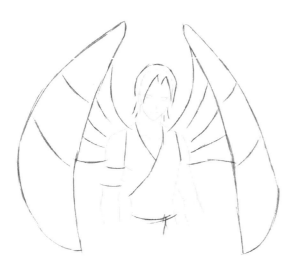

1 Draw the Basic Guidelines

Begin with the basic guidelines of the male character you drew in the Adding Details demonstration in Part 1. Now add the large triangular shapes of the left and right wings that you see here. Note that they both come to a point in an area just above his head, about one head's worth of distance away. I've added horizontal lines across the wings to help with placing feathers in the next steps.

2 Add the Feather Shapes

Now you can begin to add the long, bladelike feather shapes. Note the way the feathers overlap each other, one lying slightly above the other in a steadily repeating pattern. Take your time. Drawing wings requires patience, and rushing things will yield a poor result.

3 Add the Final Details

This step is all about details. I've chosen to add texture to many of the individual feathers as well as masses of tiny feathers across the upper edges of each wing near his shoulders. The clothing details you see here are a mere suggestion. By all means, make it your own.

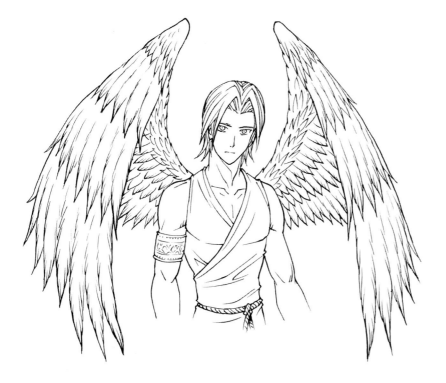

4 Ink the Drawing

Everything about drawing wings is more than just a little time-consuming, and the inking stage is no exception. I'd advise starting at the top of the drawing and carefully working your way downward since the chances of accidentally smearing lines are greatly increased when inking so many details. Once you've let the ink dry and erased the pencil lines, go ahead and pat yourself on the back. You've completed one of the most challenging lessons in this book!

Fancy Clothing

Manga artists love putting their characters in costumes. For some artists, if given a choice between ruffles, ribbons and lace-up boots, they'll go with all of the above. The beginning artist may gaze at such highly detailed illustrations and be mystified as to how these things are drawn. Never fear. By reusing the pose we learned in the earlier Running Poses demo, we can take a step-by-step approach and learn the tricks for drawing elaborate costumes.

1 Draw the Basic Pose and Sketch the Clothing
Go back to the Running Poses lesson and follow the first two steps to get the basic pose, omitting the laser pistol. Now you can begin sketching in the basics of the clothing in a loose way. Notice how I've used a sort of shorthand for the ruffles at this stage. All we need for now is a general sense of what it's going to look like.

2 Start Finalizing the Line Work and Clothing

Now you can begin making your way toward final line work while still keeping things relatively loose. Notice how I've tried to make the clothing react to the pose: The cloth is being kicked up into the air rather than hanging straight down. I've begun to sketch in a few of the ruffles here and there, but I'm not yet concerning myself with each and every fold.

3 Add the Final Details

Now you can go for the details. I chose to put a sort of starburst pattern on part of the dress. You can of course devise your own pattern, but make sure the lines are following the form of the cloth, turning in space as the cloth does. No need to replicate every little line of the ruffles. Indeed, if you draw something that's similar rather than identical, you'll be one step closer to drawing such details on your own.

4 Ink the Drawing

Switch from pencil to pen, and ink all the lines. Allow time for the ink to dry, then erase all the pencil lines. Come to think of it, there may be a second tip hidden within this lesson: Think carefully before giving a character a super-complicated costume. You're going to have to draw all that stuff again and again and again!

Fantasy Armor

We've already devoted a couple of lessons to characters wearing sci-fi-themed clothing. But maybe you're more into medieval fantasy stories, and if you are, it won't be long before you need to draw a character wearing armor. As with so many things, manga artists put their own spin on the idea of armor, often presenting dazzling shapes and surfaces that are miles away from the suits of armor you find in history museums. In this lesson, we'll reuse the pose from the Standing Poses demo to learn a step-by-step method for drawing manga-style armor.

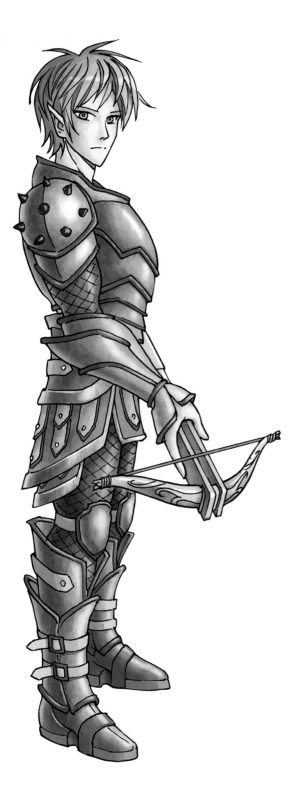

1 Draw the Basic Pose and Sketch the Armor
Go back to the Standing Poses demo and follow the first two steps, omitting the futuristic rifle. Now begin sketching the basic forms of the armor. I've chosen to make boots and gloves that fit up and away from body parts beneath them. I've also put in the rough indications of a crossbow just for fun. As always, my concern is with the big basic forms, not the details.

2 Design the Armor

Now for the fun part: designing the actual armor. My approach is to take the basic structures from the previous step and cut them up into multiple layers. Since you're not bound by the rules of real, historical armor, you can feel free to experiment and come up with whatever shapes please you. Straps on the boots? Sure! Spikes on the shoulder? Well, why not?

3 Add the Final Details

With the most important structures in place, you can move on to the final details. I opted for a simple checkerboard pattern to convey areas of chain mail. Notice how the lines curve to reveal the form of the body beneath. I find that doubling up the lines along the edges of various parts helps to convey trim throughout the design, a little touch that makes a surprisingly big difference.

4 Ink the Drawing

Grab your pen, and ink all the lines. Allow time for the ink to dry, then erase all the pencil lines. While drawing fantasy armor doesn't require study of actual historical armor, it certainly doesn't hurt to use such things as reference. If your imaginary armor is grounded in reality to some degree, people may see it as more authentic and believable.

Panels and Page Layouts

There's always more to be learned about panels and page layouts. Read on for four pieces of useful advice on this subject, all of them developed from my own experiences creating books for the last twenty years.

Leave Space for the Speech Bubbles

Dialogue can be added to comics with computer programs, allowing you to make changes easily. The danger, though, is that art can get blocked if you're not careful.

Before Adding the Text

Here is a nice panel of art, all ready for speech bubbles. Or is it?

After Adding the Text

There wasn't enough space for the text, and parts of the art aren't visible.

Space for Both the Art and Text

Ideally, the artist has anticipated the speech bubbles yet to come and makes sure to leave space for them.

Keep the Background in the Back

One of a manga artist's jobs is to maintain clarity in the art. Make sure your reader doesn't have to struggle to see what needs to be seen.

Lack of Clarity

The background art is calling so much attention to itself, it's stealing the thunder of the foreground character.

Clarity Restored

Here the foreground character is silhouetted against the sky. The background "stays back," and the effect is more pleasing to the eye.

Avoid "Talking Heads" Syndrome

In dialogue scenes, it can be tempting to just keep drawing the characters' faces again and again, panel after panel. Trust me: I've done it myself! Compare these two page layouts to see the benefits of avoiding too much of the same thing on a single page.

Talking Heads Syndrome

The talking heads version does the job, but it's a dull page, both to look at and to read.

Interesting Varied Views

Mixing in long shots and aerial views helps to liven things up considerably.

Save the Big Panels for the Big Moments

An important aspect of page layouts is deciding which panels deserve to be bigger than the others. Compare these two layouts to see how panel size relates to the effect readers get.

Small Crash Scene

The crash has been relegated to a small panel, reducing its impact on the readers.

Large Crash Scene

Enlarging the crash panel gives the moment the intensity it deserves.

Using Photo Reference

Professional artists routinely use photo reference, even when doing illustrations for fantastical stories, rather than try to draw everything entirely from memory. But what exactly does it mean to "use reference"? There's more to it than simply copying every detail of a photo. In this lesson we'll see how a photo like the one seen here can provide the basis of an illustration, helping the final product to have a look of authenticity.

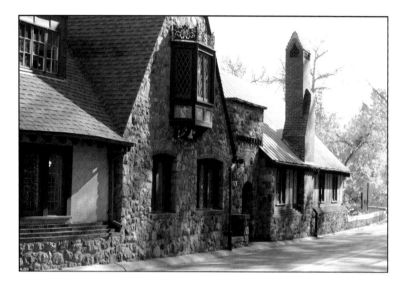

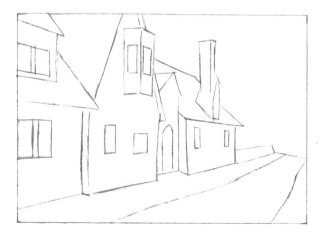

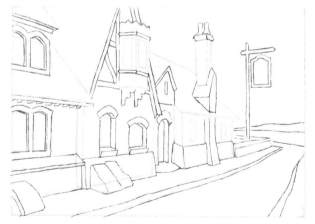

1 Draw the Basic Guidelines
Having found a suitable photo, you can begin with basic guidelines inspired by what you observe in real life. In this case we're looking at a photo of an actual location in Michigan, but one that has a sort of an old English look to it. At this stage it's all about basic structures and reproducing perspective as it occurs in the real world.

2 Develop the Drawing, Choosing the Elements You Want
As you begin building on top of the initial guidelines, you can give yourself the freedom to not draw everything just as it is in the photo. For example, I wanted the chimney to be more conventional in appearance, so I altered the top part of it for a more classic look. Some changes are even more drastic. I replaced the distant trees in the photo with a clear view to the horizon.

3 Add the Final Details

As always, I save the little details for last. At this point the illustration really comes into its own, becoming quite a different thing from the reference photo. Most of the changes I made involved taking this old-looking building and making it look older still. The photo is there for you as a starting point. Don't let it hold your illustration back by clinging to every one of its details.

4 Ink the Drawing

By the time you reach the inking stage you may be disregarding the original photo altogether. So why even bother with photo reference? Well, it supplies you with crucial little details you might not have envisioned on your own. The fancy bay window, the overall perspective, even the angle of the roof—all of these things feel right in the drawing because they are derived from their counterparts in the real world.

5 Add Color or Toning

Here we see the illustration as it might appear in one of my comics. I used a computer program to add gray tones, but you might prefer markers or colored pencils or to leave it as a pen-and-ink illustration. Next time you need to draw anything at all, not just a picture similar to this one, do yourself a favor and check out some photo reference. Most professionals swear by it.

Fitting Your Character Into a Setting

It's one thing to draw your characters standing in the middle of a blank page. It's quite another to make those same characters fit properly into an environment. Get it wrong, and it's like they're floating a little or somehow on a plane of existence that is disconnected from all the stuff surrounding them. Follow this lesson to see how you can get a character to look right at home in the location they're meant to be a part of.

1 Draw the Basic Form of the Bench

When your goal is to make sure your character is lining up properly with his or her environment, it's best to begin by drawing the object they're interacting with. In this example I want to draw a guy sitting on a bench. The guy can wait. First thing I need to do is draw the bench.

2 Add Lines for the Character's Legs

Many artists tend to always draw characters by beginning with the head and working their way down to the feet. But when fitting your character into a location, it's better to start with the feet and work your way up. Here you can see how I've taken care to line the feet up with the support structure of the bench. Then I made sure the knees were in just the right place for the legs to bend naturally across to the bench's horizontal surface.

3 Draw the Upper Body and Head

Only now do I concern myself with the upper body and the head. Having determined the size of the legs, I must take care not to make the rest of the body too large or too small. In a very real way, everything has been dictated by the size of the bench. It determined the distance of the foot to the knee, and thereby had an effect on every other aspect of the man's pose and anatomy.

4 Add the Final Details

Having worked my rough guidelines to the point where the figure and the bench look right together, I can safely move on to the details, not just for the character but also for the bench. In this sense the two parts of the drawing evolve together, one informing the other as the illustration progresses.

5 Ink the Drawing

And so we come to the inking stage. I won't pretend that any of this is easy. Even just drawing an everyday object like a bench presents challenges, to say nothing of all the clothing wrinkles you see in this drawing. But if you follow the general principles of this lesson and let your setting dictate the way you draw your character, you'll go a long way toward getting characters and locations to harmonize with each other as they should.

Tips on Adding Color

One subject that has been conspicuously absent from the *Mastering Manga* series until now is that of adding color to manga drawings. The truth is learning to draw well is a huge task, and trying to tackle color while you're still working on the basics can quickly lead to frustration. And while I couldn't possibly cover every aspect of color in this book, these pages and the two step-by-step lessons that follow will get you off to a good start.

Warm Colors and Cool Colors

Color can be used to achieve so many different effects, but one of the most fundamental ones is that of conveying warmth or coolness. Have a look at these two drawings that are identical in every way except for the colors.

A good artist thinks of these temperature effects when choosing colors. Is your picture all about loneliness and isolation? Go for the cold colors. Want the mood to be upbeat? Warm colors are what you need.

Icy Blue

Generally speaking, blue is a cold color, and the two colors nearest to it on the spectrum—purple and green—give off a similarly chilly vibe. No doubt about it: our space explorer has arrived on a subzero-temperature planet.

Red Hot

But wait. By changing all the colors to yellows and reds we can make the thermometer boil. Yellowish shades of green can also come across as fairly warm, but the yellow in them is the key.

The Two-Color Way

Coloring a manga-style illustration doesn't need to be complicated, especially if you like the cel-animation look of the anime you see on TV. In fact, many professionally rendered anime characters display a minimalist two-color approach.

Base Color

As an example of the technique, I've taken a sample illustration and colored it in using just four colors. The result, predictably, is rather dull and certainly doesn't read as the real deal for an anime fan.

Shadow Color

Here's the same illustration with just four more colors added, each of them a slightly darker version of the color they rest upon. The improvement is dramatic.

Shadows Can Have Colors Too

Most people are used to thinking of shadows as colorless things, but artists approach them with a different point of view. Have a look at these three illustrations to see how shadows need not be devoid of color.

Black Shadow

Here we see what might be called the "default" treatment: a shadow that is the same as one you'd see in a black-and-white illustration.

Purple Shadow

Now we've taken that same shadow and colored it a shade of purple. Better? Well, maybe it is, or maybe it isn't. But you should at least know you have it as an option.

Brown Shadow

Here I've colored it brown, but really almost any color could work. A professional artist experiments with all the various possibilities before deciding which will work best in the finished illustration.

With Colors, Less Is Often More

It's tempting with a rainbow of markers or colored pencils in front of you to try to use every single one of them in your illustration. But depending on your tastes, you may find that reducing both the number and the intensity of the colors in your picture gives you a better final result. As with all things art-related, it's a matter of opinion. But you should at least play around with controlling the number of colors you use in any given illustration.

Every Color Available

Here you see an illustration with what might be called "Easter egg" colors. Every single color in the rainbow is represented, and there seems to be no pattern. Everything is of equal importance, and so, in effect, nothing is important.

Muted Colors

In this version the color has been dialed back dramatically. There's more of a feeling of choices being made: The buildings have bland colors while the foreground character gets a flash of orange hair, calling our attention to her.

Coloring With Markers

There are many different art supplies you can use to color an illustration, but for many manga fans, markers are the most popular. Sadly, not all markers are created equal, and the inexpensive ones sold in drugstores and supermarkets are generally of very poor quality. To get good results, you need quality artist's markers sold at specialty art or craft supply stores.

In this lesson I'll show you my approach for using markers to color an illustration using the line art from the Sci-Fi Characters demonstration in Part 1 as an example.

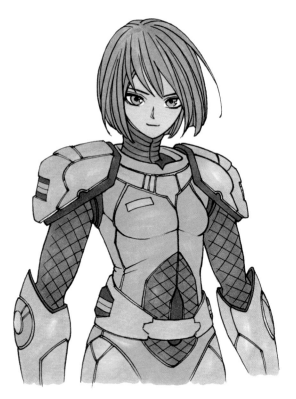

1 Start With a Flat Base Layer
I always start with a flat base layer, doing my best to cover each area all at once to keep the color smooth. If you're unsure about which colors to choose, try printing out a couple of photocopies to experiment with different color schemes before adding color to the pen-and-ink original.

2 Cover the Entire Image With a Single Layer of Color
I continue like this until I've covered the entire image with a single layer of color. It's not about creating three-dimensional effects at this stage. The main goal is to establish the color scheme and to have a foundation of color that I can build on.

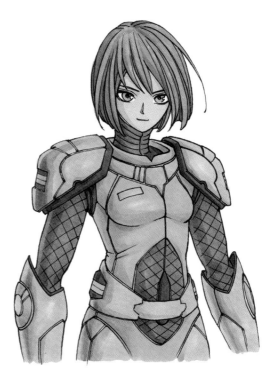

3 Add a Second Layer of Color for Shadows
Now I go back and begin adding a second layer of color, this time focusing on shadows. In this example the light source is on the right, so all the shadows go on the left. In the area of the hair, it's a simple matter of going back in with the same marker. In the area of the shoulder pad, I've switched to a slightly darker marker.

4 Continue Adding Shadows
I continue adding shadows until I've worked my way across the whole illustration. I'm deliberately keeping things a little light, knowing that I want to be able to come back and add more color on top of what I already have.

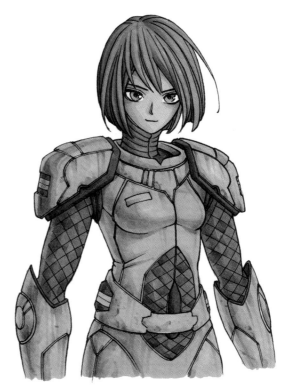

5 Add a Third Layer for Texture and Details
This last layer is mostly about texture and detail. In this example that means adding stains and imperfections in the armor. In other illustrations the final goal might be different— not so decayed looking, let's say—but the same principle applies: I wait until the end for the details since it's easier to see where they belong at this stage.

6 Take Care Not to Overdo It
And so I continue until the coloring work looks finished to me. Knowing when to stop is a challenge. When in doubt, stop working and take a break. Later on you'll be able to come at it with fresh eyes.

Coloring With Computer Programs

Giving advice on computer coloring presents a number of challenges. Different people have different programs, some of which are incredibly expensive, and I don't want to bias my advice in favor of one program or another. Also, I would guess the majority of computer colorists are largely self-taught (I certainly am), which means that everyone can, and should, come up with his or her own ways of doing things. With all that said, here is a step-by-step tutorial showing one possible way of adding computer coloring to an illustration.

Start With an Inked Drawing

Start with the final image from the Making the Manga Eye demonstration at the beginning of the book.

1 Add the Skin Base Layer

Begin by scanning the line art into the computer and then putting down a base layer of color for the skin. My approach is to cover the entire area with color and then to delete the color from the area of the eyes. This can be done with a stylus and tablet, or just by pointing and clicking with a mouse.

2 Add the Eyes Base Layer

Now put down a base layer for each of the irises. You can use any color you like, but make sure it's fairly pale since you'll be building on top of it later. Most art programs allow you to work on different layers, giving you the option to quickly change one thing—like the color of the eyes, for example—without affecting everything else in the illustration.

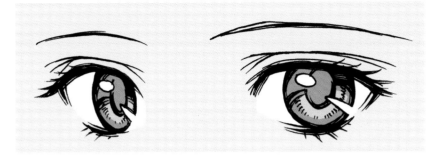

3 Add a Darker Shade to the Eyes

At this stage we can add a darker area of color to the irises, covering the upper half of each one as well as creating a small band of color along the edges. Be careful to leave the highlights white as this gives the eyes their shiny effect.

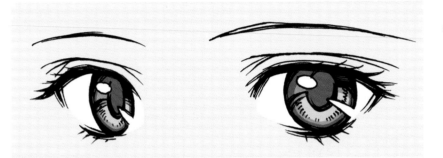

4 Add the Darkest Shade to the Pupils

If you like, you can go in at least one more time with an even darker color, filling in the areas of the pupils and perhaps adding one more narrow band of color around the edges of the irises. This refines the look of the eyes, adding beauty and depth to them.

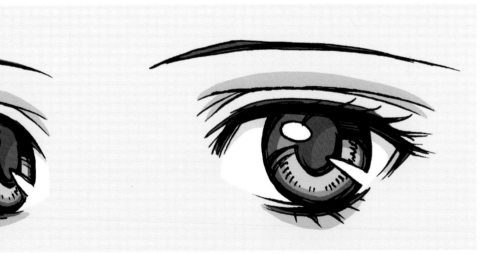

5 Add Shadows to the Skin

Choosing a shade of skin color that is just a touch darker than the one you used in step 1, add extra areas of color around the folds of the upper eyelids and below the lower eyelids. I also added dark brown to the eyebrows. One last touch you see here is a pale blue-gray shadow along the top whites of the eyes just below the upper eyelids.

Congratulations! You've used your computer to color an illustration and in doing so have begun to learn the ropes of this hugely important coloring method.

Adding Shadows

One way that artists make drawings seem more solid and three-dimensional is to add shadows to them. For a beginning artist the question of knowing where to place shadows within a drawing can be a little mystifying. To shed a little light on the subject (bad pun alert!) I've taken the character Anra from my graphic novel series *Miki Falls* and shown where the shadows would go in four different lighting scenarios.

Light From One Side

In this common lighting situation, light comes from the upper left. The shadows fall on the lower right-hand side of things, whether it be the head, body, legs or tail. Note that the drop shadow is darkest in the areas that are nearest to Anra. In the areas farther away, light spills in and reduces the darkness of the shadow.

Light From Below

I've added a grid here to help convey the idea of all the light coming from below. Naturally the shadows must now move to the top of Anra's head, body, legs and tail. Since it is an unusual lighting situation, the final effect tends to be one of drama or even spookiness.

Light From Behind

Light from directly behind might create an eclipse effect, more or less like a silhouette. In this case the light is from behind but a touch to the left, allowing us to see a crescent of light on the left-hand side of Anra's body. The drop shadow must move forward on the floor to account for the direction of the light source.

Light From Two Sides

Here we have a more complex but common lighting situation. In this example the dominant light is coming from the left, creating shadows on the right. There is a second light source on the right, just bright enough to illuminate the far right-hand side of Anra's body. As a result, there are two drop shadows on the floor. The one on the left is less intense since it is created by a dimmer light source.

Methods for Rendering Shadows

When it comes to adding shadows to an illustration, artists have many possible techniques to choose from. Have a look at how this simple line drawing of a hooded figure can get the shadow treatment by way of four very different methods.

Line Drawing

Bold Black

With this approach the artist draws a sharp line between light and shadow and proceeds to fill in the shadowed areas with solid black. It's a daring choice. As you can see here, it sometimes results in sacrificing details. His eyes may be there, but in this version the viewer is unable to see them.

Screen Tone

Most published manga you see today employs screen tones to some degree: shades of gray that are created by way of thousands of tiny dots. Though some people still attach these tones by hand, it is becoming more common to achieve the effect by way of computer programs.

Crosshatching

Here you see all the shadows rendered by rows and rows of parallel lines joining together to simulate an area of gray. It's a time-tested technique and can be very beautiful when executed by a master. Even a manga that relies a lot on screen tones will often also make use of crosshatched shadows.

Pencil

As far as published manga goes, a book done with pencil rather than ink is rare indeed. Still, shadows can be very nicely rendered with pencil, and you may find this approach useful for cover art and other such "beauty shot" illustrations.

Designing Your Manga's Logo

When I'm working on a new manga story, one thing I like to do early on is come up with a logo: the way the title might look on the front cover once it's published. I find it's a great way of motivating myself. Having a logo makes the whole project seem more real, like it's just one step away from hitting the bookstore shelves.

Now, any font geek will tell you that the lettering used in every situation—even the lettering you're reading right now—has an influence on how you feel about the words you're reading. So you need to think about the prevailing mood of your story, then find the lettering that best conveys that mood.

Let's have a look at the words *Sample Logo* written in a variety of styles, and see what kind of moods they convey.

Brushy Lettering

Here we have lettering that looks like it was painted with an old calligraphy brush. There's something organic and primal about the look of it, and the jagged edges seem to promise a world that is raw and untamed. If I wanted to write a story set in a mysterious kingdom where ancient ways have gone on unchanged for thousands of years, this is the kind of logo I might come up with.

Futuristic Lettering

Well, the two words are the same, but we sure are getting a different feeling this time, aren't we? All the lines are clean and sharply italicized, suggesting a kind of high-tech precision untouched by human hands. If I saw a logo like this, I'd think I'm about to read a sci-fi action story or perhaps a tale of cutting-edge espionage.

Fantasy Lettering

Of course, a logo can be more than just lettering. By working a drawing of a sword into this version, I'm pretty much promising the reader that swords will be at the heart of the story. The lettering has the look of centuries-old texts, leading the reader to expect a tale that, like *The Lord of the Rings*, will at least have echoes of Europe in the Middle Ages.

If you're already working on a manga story of your own, why not try coming up with a logo for it? You may find it motivates you to carry on and get the story finished.

Designing Cover Art

Forget what they say about not judging a book by its cover. The fact is that in the eyes of the publisher, the front cover art is the single most important image that will be associated with your story. In this sense it may well be the one that gets the most thought and goes through the greatest number of revisions.

Here are some things to keep in mind when you sit down to design the cover art of your manga.

Thumbnail Sketches

Never launch straight into the final art with the first idea that pops into your head. A professional artist does lots of thumbnail sketches, gradually arriving at the composition he or she likes the best.

Cover Thumbnail Sketches

Here are some of the thumbnail sketches I drew for the cover art for *Brody's Ghost* Book 6. In the two sketches on the left I played around with various elements in different locations and at different sizes. Neither are terrible designs, but they didn't convey the end-of-the-road quality of the book. I finally arrived at a bold design that placed the Penny Murderer character front and center. Make sure you go through a similar process, considering lots of different possibilities.

Cover Art vs. Interior Art

When you're creating art for your page layouts, the rhythm of the scenes dictates everything. Your main concern is how each panel works as a team member, to create the best possible storytelling flow. The cover art is more like a soloist. It's out there on its own, and it can't be just another snapshot of a moment from the story.

Interior and Cover Art Comparison

Here are two versions of the *Brody's Ghost*, Book 3 cover art. On the right is the actual published cover. On the left I've tried to make a piece of art from the interior work as a cover. The characters are too small and have their backs to the reader. Publishers want the characters to occupy a large percentage of the cover with the characters' faces visible.

As you consider different designs for your manga's front cover, make sure it is your choice, not just another drawing. It has to be bold, memorable and make people curious to see what's inside.

Make Your Own Front Cover

Here we are at the fortieth and final step-by-step lesson, so let's make it something special. It's time for you to design the front cover of your own manga. Not just the artwork, but the logo too. Let this lesson bring together everything you've learned so far about creating characters, putting them into poses and even adding color.

1 Design the Logo
Start by designing your manga's logo. Need help with lettering? Look at the different fonts on your computer for ideas. And don't go with the first version that comes to you. Try at least a few different designs and then choose the one you like best.

2 Try Some Thumbnails
Now do a few thumbnail sketches of possible cover designs. Keep them small and rough so you can make a bunch of them, exploring various possibilities. Your design doesn't need to look anything like the one I've presented in this example. Make it your own!

3 Draw a Larger Sketch
Once you've settled on a thumbnail sketch you like, redraw its basic lines at a larger scale. You can theoretically work at any size you like, but artists creating cover art typically work pretty large: the size of a sheet of office paper at the very least or bigger if you can manage it.

4 Continue Developing the Lines and Details

Continue working out the lines in pencil until you're satisfied with all the details of your final layout. For real published covers, the logo is generally done separately and then dropped in later using a computer program. But for a mock-up version like this one, there's nothing wrong with putting it all together in a single illustration.

5 Ink the Drawing

Now ink all the lines. Take your time. Good inking requires care and concentration. When it comes to cover art, it's that much more important that you deliver your best work. Let the ink dry, and then erase the pencil lines.

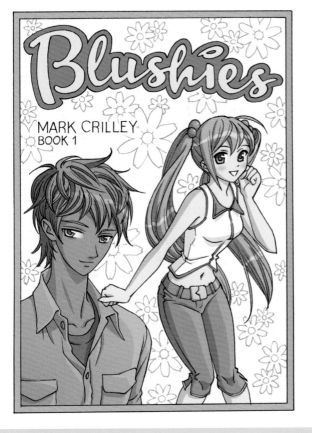

6 Color the Cover

Add color to the illustration, either by way of traditional art supplies like markers or by way of a computer program. If you're going to go the traditional route, consider testing out your color scheme on a couple of photocopies first before putting color directly onto your original pen illustration. Hats off to you: You've completed a full-color cover design, unquestionably the most challenging tutorial of the entire *Mastering Manga* series!

Index

Connect With Mark!

You Tube youtube.com/markcrilley

f facebook.com/markcrilleyOFFICIAL

DEVIANT ART markcrilley.deviantart.com

twitter.com/markcrilley

instagram.com/markcrilleyREAL

About the Author

Mark Crilley is the author of several graphic novel and prose fiction book series, including thirteen-time Eisner nominee *Akiko*, *Billy Clikk*, *Miki Falls* and *Brody's Ghost*. He is also the author of bestselling *Mastering Manga With Mark Crilley* (IMPACT Books, 2012). Since being selected for *Entertainment Weekly*'s "It List" in 1998, Crilley has spoken at hundreds of venues throughout the world and become one of YouTube's #1 most-subscribed drawing teachers, creating drawing demonstration videos that have been viewed more than 300 million times. His work has been featured in *USA Today*, the *New York Daily News* and *Disney Adventures* magazine, as well as on *CNN Headline News* and Comcast OnDemand. Visit his website at markcrilley.com.

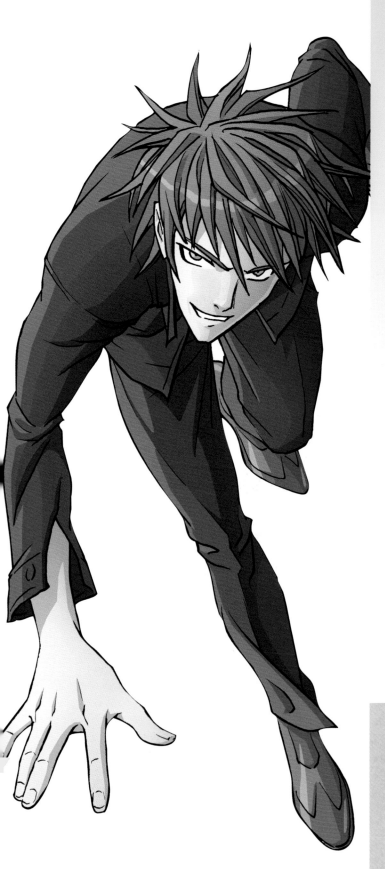

Mastering Manga 3. Copyright © 2016 by Mark Crilley. Manufactured in USA. All rights reserved. No part of this book may be reproduced in any form or by any electronic or mechanical means including information storage and retrieval systems without permission in writing from the publisher, except by a reviewer who may quote brief passages in a review. Published by IMPACT Books, an imprint of F+W Media, Inc., 10151 Carver Road, Suite 200, Blue Ash, Ohio, 45242. (800) 289-0963. First Edition.

fw a content + ecommerce company

Other fine IMPACT Books are available from your favorite bookstore, art supply store or online supplier. Visit our website at fwcommunity.com.

20 19 18 17 16 5 4 3 2 1

Distributed in Canada by Fraser Direct
100 Armstrong Avenue
Georgetown, ON, Canada L7G 5S4
Tel: (905) 877-4411

Distributed in the U.K. and Europe
by F&W Media International LTD
Brunel House, Forde Close, Newton Abbot,
TQ12 4PU, UK
Tel: (+44) 1626 323200, Fax: (+44) 1626 323319
Email: enquiries@fwmedia.com

ISBN 13: 978-1-4403-4093-2

Edited by Mary Burzlaff Bostic
Designed by Geoff Raker
Production coordinated by Jennifer Bass

Metric Conversion Chart

To convert	to	multiply by
Inches	Centimeters	2.54
Centimeters	Inches	0.4
Feet	Centimeters	30.5
Centimeters	Feet	0.03
Yards	Meters	0.9
Meters	Yards	1.1

Ideas. Instruction. Inspiration.